DRAW REALISTIC CLOTHING
AND PEOPLE WITH LEE HAMMOND

NORTH LIGHT BOOKS
CINCINNATI, OHIO
ArtistsNetwork.com

Contents

· · · · · · · · · ·

WHAT YOU NEED

- 0.5 mm mechanical pencil
- assorted paper
- drawing board
- kneaded eraser
- horsehair drafting brushes
- paper clip
- Pink Pearl erasers
- reference photos
- rulers
- smooth bristol boards
- stick erasers
- stumps
- tortillions
- workable spray fixative

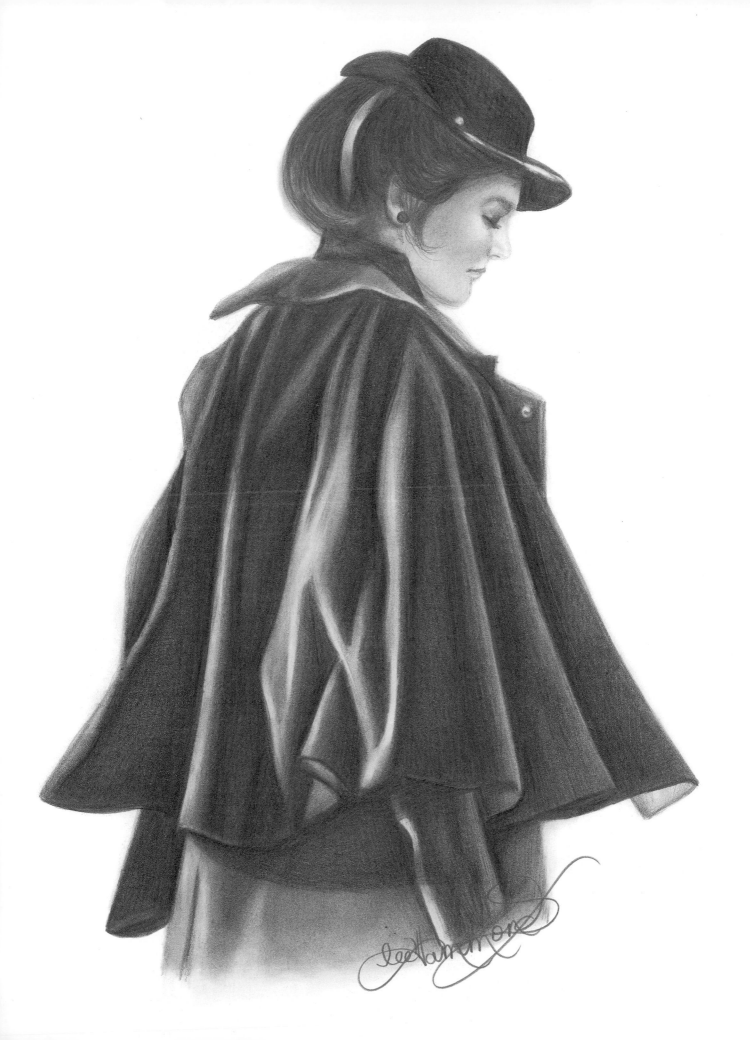

Introduction

· · · · · · · · · · · · · ·

As an art instructor, I analyze my students' work and answer their questions and concerns. I see them struggle in drawing particular subjects, and I know how hard certain things can be to draw. I was a beginner once myself, and I never forget how frustrating it can be.

One of the most difficult things to draw is realistic and believable clothing. Even after I have taught my students the basics of portraiture, oftentimes their drawings fall short when the clothing is applied. Rarely does the student have the knowledge to make the clothing as believable as the portrait itself. If this is true for you as well, then you are not alone!

It is my intention, with this book, to alleviate some of the frustration associated with drawing fabric. I want to take the mystery out of it and give drawing clothing an easy-to-follow process. All it takes is an understanding of what to look for and the right amount of practice—that is what the projects in this book are designed to do. If the projects and exercises are done in the order they are presented, I guarantee you will have pleasing results!

Learning anything new can be learning "what *not* to do" more than anything else. It is no different when learning how to draw fabric and clothing. I see the same mistakes made repeatedly in my students' work. These errors are really about perception and observation: The students simply do not fully understand what it is they are actually drawing.

The biggest mistake I see is the use of too many hard lines. It is important to remember that fabric is one surface, wrapping around the human form. Only when it is creased, folded or overlapping something will you be using a hard line to depict it. Otherwise, it should be created with the use of gentle shading.

You will notice that there is very little of the face shown in the artwork of this book. It is my goal to make you proficient in clothing—not portraiture. Portraiture is a whole different, difficult subject. I would recommend referring to my book *How to Draw Lifelike Portraits from Photographs* to learn how to draw the face. The two books complement each other very well.

Using these proven techniques—that I have used in more than three decades of teaching—I will show you how to realistically capture the human form and create the look of believable clothing. You must train your eye, and this doesn't happen overnight. Take your time and study the material carefully. Remember: Practice is the key to learning!

The look of this smooth fabric is created with blending.

A Smooth Cashmere Sweater
11" × 14" (28cm × 36cm)
Graphite on smooth bristol

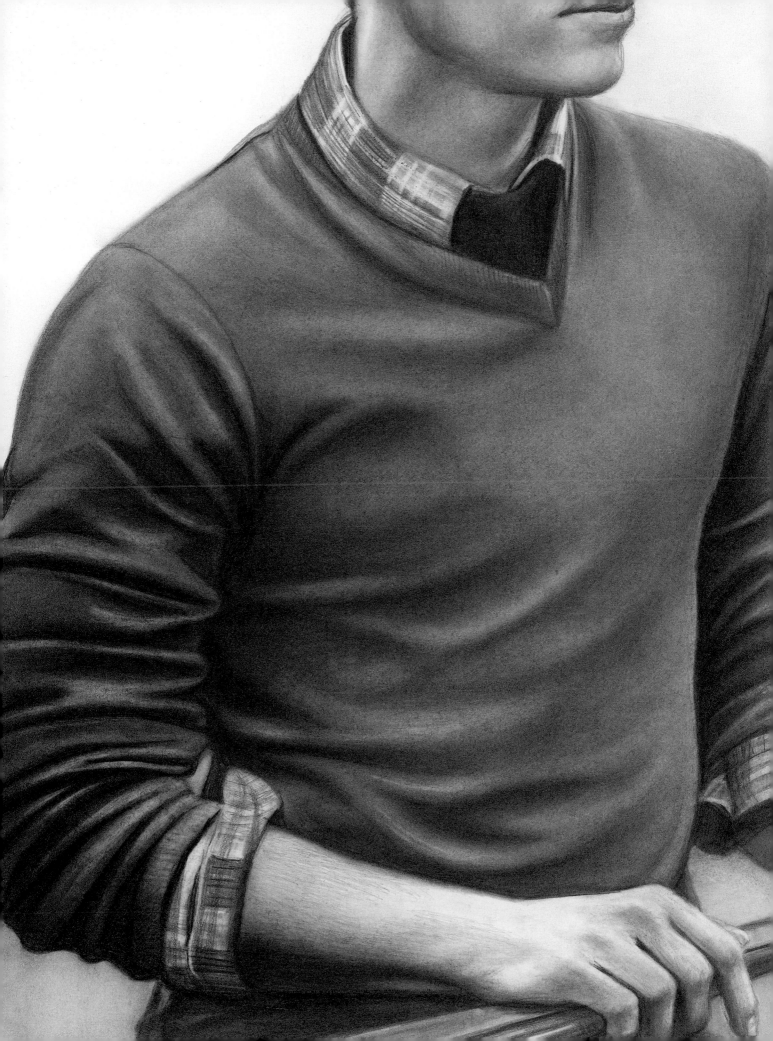

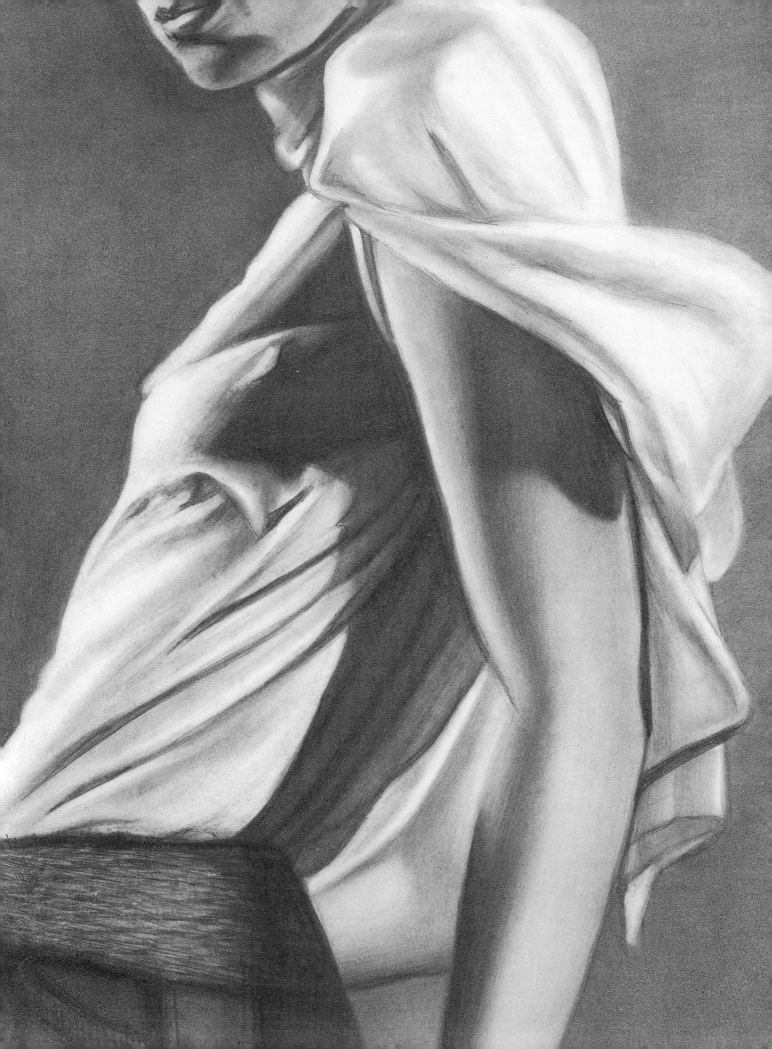

You Can Do It!

There is a familiar format to every one of my books. The beginning chapters are similar because the foundation to all good drawing starts with the same basic principles. While it may be tempting to skim over this material, I would highly advise that you don't. It is in these exercises that your skills will be tested and your abilities advanced.

While it may seem repetitious (which it is), it is important to remember that repetition is the key to learning. So, it bears repeating that practice is essential to growth. The more you do, the better you will become.

While I am hardly a beginner anymore, I am still growing as an artist. Because I am a teacher, I not only have the privilege of sharing my methods, but I also gain more experience by drawing every day. I have learned so much by teaching; when you have to demonstrate something, and explain it, you also understand it better yourself. My constant reference to these opening exercises for beginning students cannot be emphasized enough. The more you do, the better you will become.

If you feel intimidated—don't! Forge ahead with determination and you will do just fine. The following pages will show you how some of my students went from awkward beginners to confident artists in a short amount of time.

You can do it!

Fashion Model
11" × 14" (28cm × 36cm)
Graphite on smooth bristol

Before and After Examples

The following examples are real, actual illustrations from some of my students. I chose them because the students were beginners when the pieces were created, and although they were proficient, they lacked the knowledge and experience to draw believable clothing on an accurately depicted human form.

When looking at these examples, note the common mistakes in their first attempts. Both students struggled with a similar issue—the overuse of hard lines. Only in certain areas should a hard line be used; the rest is done with gradual shading. We will talk about this more later on.

The second noticeable error is in the shading. Both examples appear choppy and uneven. Since most fabric is smooth, gradual blending is very important. Likewise, the shape of the body's contours must be seen within the fabric as well. When drawing clothing, you are actually drawing two things at the same time: the clothing and the body. They work together, one affecting the other.

Both of these students advanced rapidly once they remembered the importance of controlled blending. While this is information that they already knew, they had never applied it to fabric before. All it took was some guidance and understanding, plus a lot of practice. You can do it, too!

LEE'S LESSONS

The overuse of hard lines is the most common mistake when drawing fabric. For when our eyes see changes in the surface of something, we tend to draw a line to depict that change.

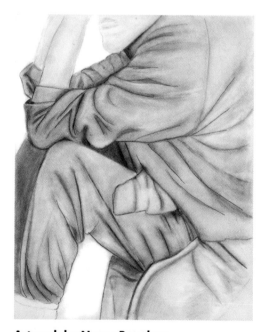

Artwork by Nancy Boughan

BEFORE
The student used too many hard lines to depict this jogging suit.

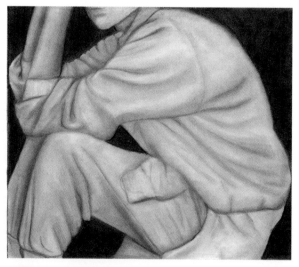

AFTER
This second attempt looks more realistic due to the use of blending and the reduction of hard lines. Using a dark background also helped to create the light edge of the fabric and removed the need for outlining.

Visit ArtistsNetwork.com/draw-realistic-clothing-and-people for bonus materials.

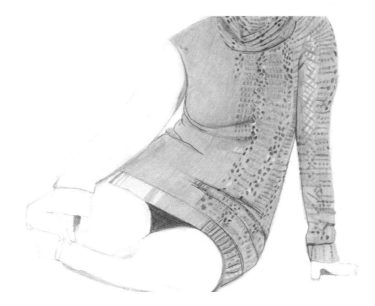

Artwork by Kathy Donahue

BEFORE

The texture of the sweater really confused her, and she basically gave up, feeling overwhelmed. This is the stage where many just quit.

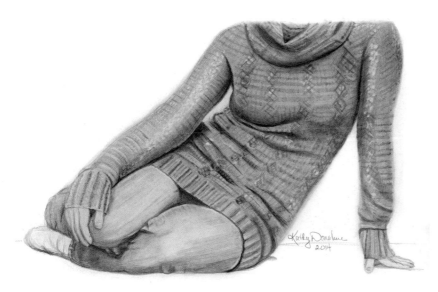

AFTER

Texture always comes last. It should never be applied to the white of the paper, and the form must be created with shading first.

Before she was trying to be too literal with the patterns of the sweater. Here, she has allowed illusion to help create the look. More emphasis was placed on the form, which makes it appear more realistic.

PULLED FABRIC

Fabric creates ripples and folds everywhere it is pulled and stressed. Even a smooth shirt becomes extremely varied in its surface when stretched over the body.

Sign up for our inspiring and free newsletter at ArtistsNetwork.com.

9

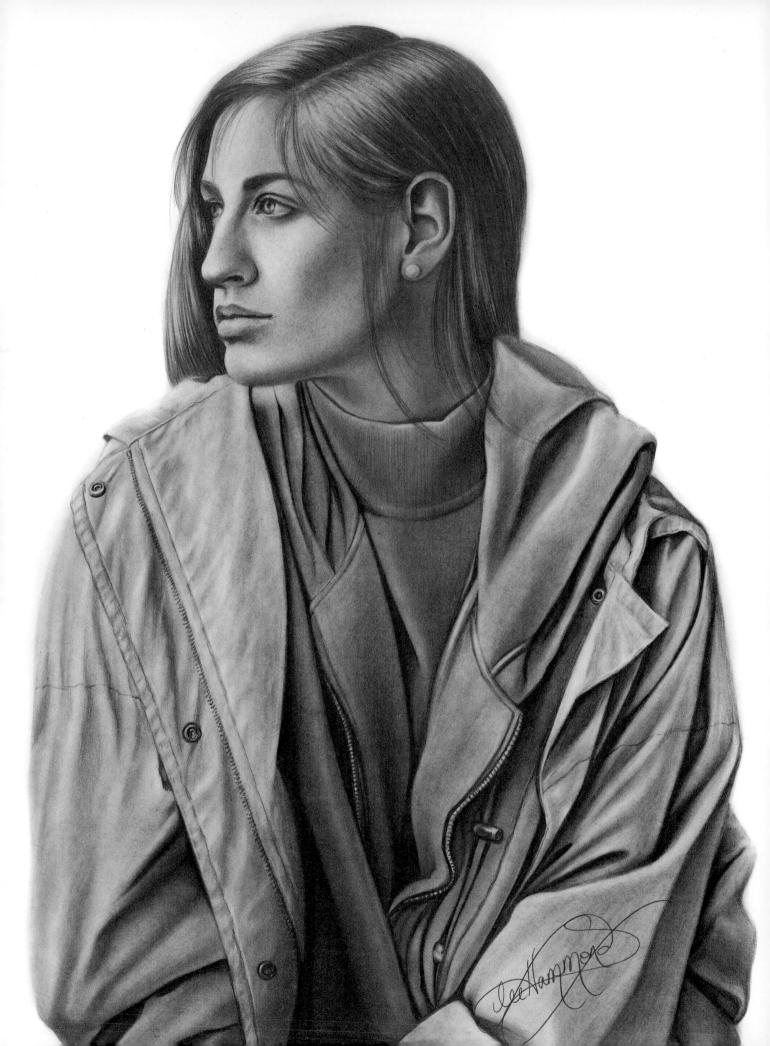

Getting Started

Everyone has a style of their own. I invite you to experiment and find your personal approach. Even though I am teaching one particular style, I still see variety among my students. I could probably take all of my students' works and place them together on a table, and tell you who did what without seeing their names. Although the style may be similar, all students have a very distinct look about their work that sets them apart. That's the way it should be!

The most important thing about this particular style of drawing is the blending. It is what gives the art a realistic, polished look. The tones appear seamless. Knowing how to see the light and where to place the shadows is the key.

The second important aspect is the capturing of shape and form. An accurate line drawing is essential as the foundation of your work, for it is what the shading is built on. Without accuracy in your line drawing, the entire drawing will suffer.

To learn something new, it is always good to start with the easiest steps. When learning to drive, we practiced going backwards and forwards in the driveway before we hit the interstate during rush hour—an experience such as that could be so traumatic, we might never want to drive again! The same theory applies to drawing. I've seen beginning artists dive right into very complex projects. Unfortunately, they usually quit drawing altogether—claiming it is just too hard!

So, we're going to focus on the easier things first, like basic shapes. All you need to know to begin is how to draw a sphere and a cylinder. From these basic shapes, you will learn how to draw the contours seen in the human body and the clothing the person is wearing.

Take some time to really practice the information in this chapter. All of this material is what makes or breaks the skill of an artist. By starting with just the basic shapes, and practicing the rendering techniques with the five elements of shading, your skills will grow.

From *How to Draw Lifelike Portraits from Photographs* by Lee Hammond

Windbreaker
14" × 17" (36cm × 43cm)
Graphite on smooth bristol

Sign up for our inspiring and free newsletter at ArtistsNetwork.com.

11

Materials for Working in Black and White

· · · · · · · · · · ·

You cannot create quality artwork with inadequate art materials. My blended-pencil technique requires the right tools to create the look. Don't scrimp in this department or your artwork will suffer.

I've seen many of my students blame themselves for being untalented when it was their supplies keeping them from doing a good job. The following tools will help you be a better artist.

- **Mechanical Pencil**
 Mechanical pencils are great for fine lines and details, and you never have to sharpen them.

- **Smooth Bristol Board or Paper—Two-Ply or Heavier**
 This paper is very smooth (plate finish) and can withstand the rubbing associated with a technique I'll be showing you later in the book.

- **0.5mm Mechanical Pencils With 2B Lead or Softer Lead**
 While a mechanical pencil is my pencil of choice, the lead is the most important part. 2B is a soft lead that offers a smooth blend. You can also use 4B or 6B with similar results.

- **Blending Tortillions and Stumps**
 Both of these are used for blending the graphite. Tortillions are spiral wound pieces of paper that are good for small areas. Stumps are pressed and formed paper in the shape of a pencil, and pointed on both ends. They are good for blending larger areas.

- **Kneaded Erasers**
 These erasers resemble modeling clay and are essential to a blended-pencil drawing. They gently lift highlights without ruining the surface of the paper.

- **Stick Erasers**
 These erasers resemble mechanical pencils with a click mechanism for advancing them. The erasers in these are made of vinyl and they erase pencil marks cleanly. The small point of the vinyl eraser can remove precise lines and details within your drawing. They come in a variety of sizes, from large tips to micro.

- **Horsehair Drafting Brushes**
 These brushes will keep you from ruining your work by brushing away eraser excess with your hand and smearing your pencil work. They will also keep you from spitting on your work as you blow away the eraser excess.

- **Pink Pearl Erasers**
 These are meant for erasing large areas and lines. They are soft and

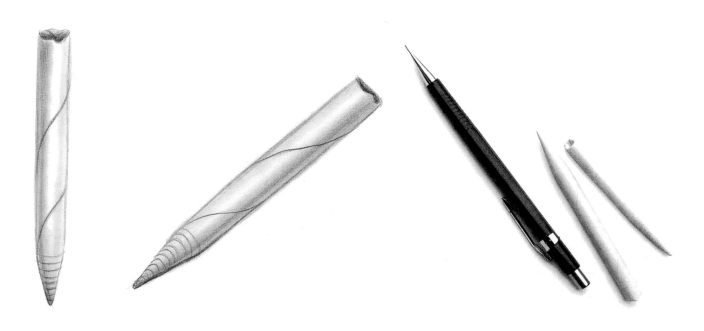

nonabrasive, so they won't damage your paper.

- **Workable Spray Fixative**
 This is a spray used to seal your work and to prevent it from smudging when you are finished. While it says that it is workable, meaning you can spray down an area and continue to draw on top of it, I don't recommend it for this technique. It will change the smoothness of the paper and interrupt your blending.

- **Drawing Board**
 It's important to tilt your work toward you as you draw. This prevents the distortion that occurs when working flat. Secure your paper and reference photo with a clip.

- **Rulers**
 Rulers help you measure and graph your drawings.

- **Acetate Report Covers**
 Use these covers for making graphed overlays to place on top of your photo references. They'll help you accurately grid your drawings.

- **Reference Photos**
 These are valuable sources of practice material. Collect magazine pictures and categorize them into files for quick reference. A word of warning: Don't copy the exact image; just use the images for practice. Many photographers hold the copyright for their work, and any duplication without their express permission is illegal. You can avoid this issue altogether when you use your own reference photos.

LEE'S LESSONS

This unfolded paper clip is also referred to as my Tortillion Rescue Kit. Since a tortillion is made up of spiral wound paper shaped into a cone, if you use the tip too much, it can collapse into itself. By sticking the end of the paper clip into the tortillion, it will push the point back out.

Sign up for our inspiring and free newsletter at ArtistsNetwork.com.

13

The Five Elements of Shading

· · · · · · · · · · ·

To draw realistically, you must understand how lighting affects form. There are five elements of shading that are essential to realistically depicting an object's form. If any of these elements are missing, your work will appear flat. However, with the correct placement of light and dark tones, you can draw just about anything.

But how do you know how dark is dark and light is light? Using a simple five-box scale of values can help you decide on the depth of tone. Each tone on the scale represents one of the five elements of shading.

1. Cast Shadow
This is the darkest tone on your drawing. It is always opposite of the light source. In the case of the sphere, it is underneath, where the sphere meets the surface. This area is void of light because, as the sphere protrudes, it blocks light and casts a shadow.

2. Shadow Edge
This dark gray is not at the very edge of the object. It is opposite the light source where the sphere curves away from you.

3. Halftone
This is a medium gray. It's the area of the sphere that's in neither direct light nor shadows.

4. Reflected Light
This is a light gray. Reflected light is always found along the edge of an object and separates the darkness of the shadow edge from the darkness of the cast shadow.

5. Full Light
This is the white area where the light source is hitting the sphere at full strength.

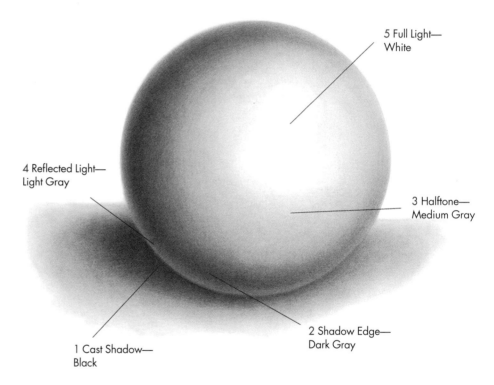

5 Full Light—White

4 Reflected Light—Light Gray

3 Halftone—Medium Gray

2 Shadow Edge—Dark Gray

1 Cast Shadow—Black

COMPARE THE TONES IN THE VALUE SCALE TO THE TONES IN THE SPHERE
Notice how the five elements of shading on the sphere correspond to the tones on the value scale. Look for the five elements of shading in everything you draw.

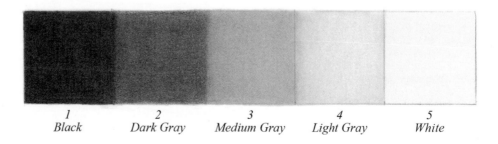

| 1 Black | 2 Dark Gray | 3 Medium Gray | 4 Light Gray | 5 White |

Create Smooth Blending

Proper shading requires smooth blending. To create smooth blending, you must first learn to use your tools and apply the pencil lines properly. If the pencil lines are rough and uneven, no amount of blending will smooth them out.

Apply your pencil lines softly and always in the same direction. Build your tones slowly and evenly. Lighten your touch gradually as you make the transition into lighter areas. Smooth everything out with a blending tortillion, moving in the same direction you used to place your pencil tone. Begin with the darks and blend out to light.

HOLD YOUR TORTILLION AT AN ANGLE
For even blending and to keep the end of your tortillion sharp, always hold it at an angle. If the end becomes blunt, poke a straightened paper clip through the top to straighten it out.

INCORRECT BLENDING
This example shows poor pencil application. The scribbled lines look sloppy, and a tortillion wasn't used for blending.

LEE'S LESSONS
Do not throw your tortillions away when they become dirty! Save them and divide them into groups according to how much graphite they have on them. A very black tortillion will be just what you need to blend out a dark area later.

CORRECT BLENDING
Apply the lines closely, then, in an up-and-down fashion, fill them in. Add tone until you build up a deep black, then lighten your touch and gradually get lighter as you move to the right.

Blend your values with a tortillion, using the same up-and-down motion you used with the pencil. You do not want to see clear distinctions between where one tone ends and the next begins. Lighten your touch as you move right and gently blend the light area into the white of the paper until you can no longer tell where it ends.

KEEP LOTS OF TORTILLIONS ON HAND
Always use a fresh tortillion for the light areas. Don't be tempted to use the same ones over and over again to conserve. They are nothing more than paper wrapped into a cone shape and are inexpensive.

Sign up for our inspiring and free newsletter at ArtistsNetwork.com.

15

Practice Blending for Actual Objects

Before you begin drawing actual objects, you should get a good feel for your tools and materials. Start by drawing some correct blended-tone swatches to help you learn to control your blending. Begin with your darkest tone on one side and gradually lighten the tone as you continue to the other side. Do as many as you need until you feel proficient at it.

Once you begin to draw actual objects, use the following guidelines to help you.

Soft Edge

This is where the object gently curves and creates a shadow edge. It is not harsh, but a gradual change of tone.

Hard Edge

This does not mean outline! This is where two surfaces touch or overlap, creating a harder-edged, more defined appearance. Let the difference in tones create the edge.

Application of Tone

Always apply your tones with the contours of the object. Follow the curves of the object with the shading parallel to the edges so you can blend into the edge and out toward the light. It is impossible to control blending if you are cross-blending and not following the natural edges and curves.

Contrast

Don't be afraid of good, solid contrasts of tone. Always compare everything to black or white. Use the five-box value scale to see where the gray tones fit in. Squinting your eyes while looking at your subject matter obscures details and helps you see the contrasts better. The sphere, the egg and the cylinder are all important shapes to understand. If you can master the five elements of shading on these simple objects first, drawing other things will be much easier.

LEE'S LESSONS

Correct an uneven tone by forming a point with your kneaded eraser and drawing in reverse. With a light touch, gently remove any areas that stand out darker than others. Use light strokes with your pencil to fill in light spots. Hone your blending skills on basic objects, like this cylinder, before moving on to more complicated forms.

CYLINDER

This is the basic shape seen most when drawing the human form, and when drawing fabric.

Basic Shapes Seen in Anatomy and Clothing

Everything we draw is made up of basic shapes. No matter how difficult the subject matter may appear, it can be made easier by seeing the shapes first and the details last.

Before you learn to draw difficult things, you must first master drawing the simple ones. Everything you need to know is in the basics.

The following illustrations show the most common basic shapes seen in the human form and in clothing. The one we will draw the most is the cylinder. Its tubelike structure is seen in the arms, legs and neck of human anatomy, as well as many of the folds in fabric.

An artist's first goal should be to draw these shapes well before ever attempting anything more difficult.

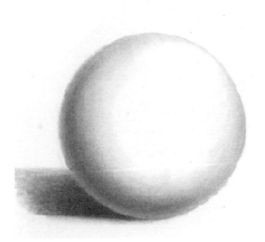

SPHERE
There is no better way to learn to properly create form than to perfect drawing the sphere.

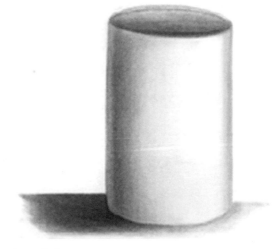

CYLINDER
This is the shape you will use the most for figures and clothing. Its structure is seen in arms, legs and necks, as well as in folds and fabric.

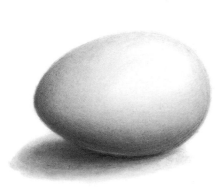

EGG
The egg shape is also essential for drawing the human form.

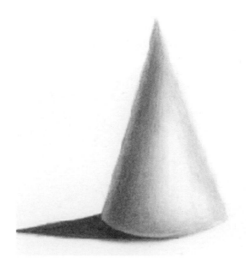

CONE
The cone shape is essential for drawing fabric and folds.

Sign up for our inspiring and free newsletter at ArtistsNetwork.com.

17

Creating Contrast

From the very beginning, we are taught in school to outline everything by "staying in the lines." This was the only way to make the subject stand out against the white of the paper. Look at a child's coloring book and it will prove my point.

My students must have the same childhood rhetoric repeating in their brains, for outlining is the hardest thing for me to teach out of them. The use of hard lines is so ingrained in our minds that it becomes one of our worst habits and one of the hardest things to override.

The background tones are just as crucial as the tones of the subject itself. Placing darkness into the background is the only way to create the look of a light edge on a subject. Look at the example of the sphere here: You can see all of the five elements of shading, but the tones in the background add an extra element of realism to the drawing.

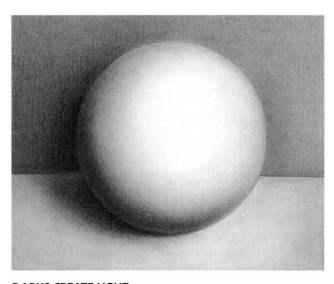

DARKS CREATE LIGHT
By placing darker tones into the background, the light edges of the sphere are illuminated, creating a more realistic drawing.

Reflected Light

Reflected light is what makes something stand out against a darker background. It is found anytime an object has an edge or a rim. Look at the edge of your sleeve or the cuff on your pants—both have light dancing along the edge.

The reflected light is evident all along the edges where the subject is light and the background is darker. You will see it where the muscle areas are slightly raised—a raised area captures more light. Placing a subject into a darkened atmosphere, as in this example, makes the drawing more interesting. It creates mood. It also creates form, since dark creates the light.

Creating reflective light in your drawing is a delicate procedure called *lifting light*. It is done with a kneaded eraser to make it look soft and natural.

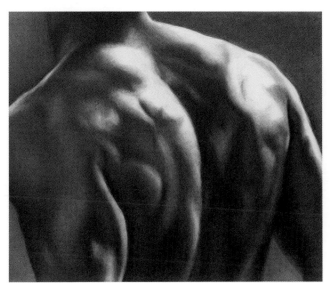

LIFTING LIGHT
Look for the reflected light along edges, and in the areas that are slightly raised or curved. The darkness of this drawing makes the light look very interesting, shining off of the body.

Three Steps to Drawing Shapes
• • • • • • • • • • • • •

There are generally three steps to drawing any object. The first step is creating an *accurate line drawing* to build on. This is a light outline of the overall shape of your subject matter, as well as the interior details. (These outlines will be hidden later with shading.)

The second step is identifying the light source and placing the tones or lights and darks.

The third step is blending. It is where you make the tones smooth and gradual with your tortillions. This is where the realism is created. It is also in this step that you lift the light.

Keep in mind that these three steps are just guides, and there may be numerous things you do within each step to make the drawing look right. The additional background tones make these exercises more complicated. Containing them in a border box will help.

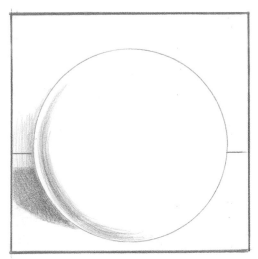

1 DRAW A BORDER, BOX AND BASIC SHAPE
Draw a border box and accurately draw the basic shape. Place a line halfway across to give the look of a table edge.

Identify the light source, and place the cast shadow and the shadow edge opposite of the lightest area. You have now created the darkest and lightest areas of your drawing.

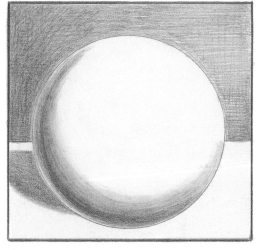

2 ADD THE TONES
Place the dark tones in the upper half of the drawing. This will establish the upper light edge of the object's shape.

Add more tone to the shadow edge, and blend it into the halftone area. Make sure the halftone fades into the full light seamlessly. Always use a clean tortillion when fading into the full light, and save the dirty ones for the dark areas.

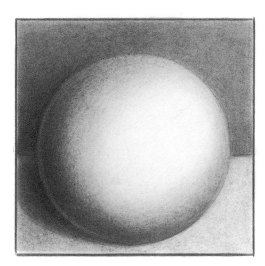

3 BLEND
Continue adding tone and blending from dark to light with the tortillions. If things look uneven, carefully fill in little light areas with your pencil, or gently lift dark areas with a pointy piece of your kneaded eraser.

Sign up for our inspiring and free newsletter at ArtistsNetwork.com.

19

Egg, Cone and Cylinder

Using the three basic steps to drawing shapes that you learned in the previous demonstration, try drawing an egg, a cone and a cylinder. You will notice that the same procedures can be used for all three steps.

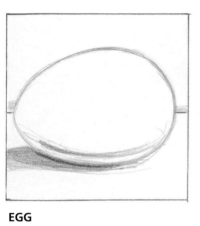 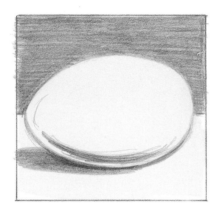 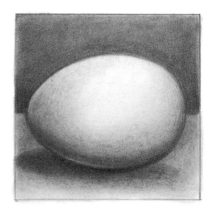

EGG

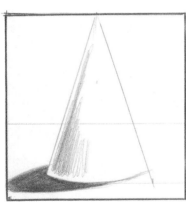 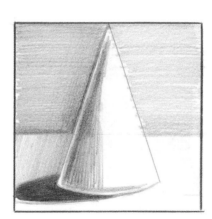 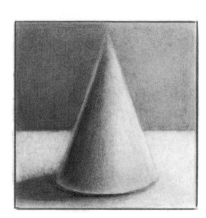

CONE

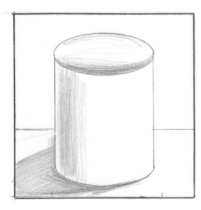 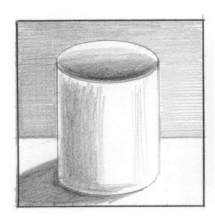 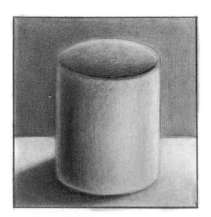

CYLINDER

Visit ArtistsNetwork.com/draw-realistic-clothing-and-people for bonus materials.

The Puzzle Piece Theory

.

Before you begin any type of blending on your artwork, it is important to give yourself a firm foundation to build on. To do this, you need an accurate line drawing.

The easiest and most educational way to draw from photos is to use a graph. A graph is a tool that divides your subject into smaller workable boxes to draw in. This exercise will help you understand how a graph works. It's fun, too, just like a puzzle!

Here we have a series of numbered boxes containing black-and-white nonsense shapes. Draw these shapes in the corresponding numbered boxes in the empty graph on the next page. You'll learn to see shapes this way.

Do not try to figure out the subject you are drawing. Once we become aware of what the subject matter is, we tend to draw from our memory instead of drawing what is right in front of us.

No matter what you are drawing, concentrate on seeing the subject as many individual shapes that interlock like a puzzle. If one of the shapes you're drawing doesn't lead to the next one, fitting smoothly together, you'll know that your drawing is inaccurate.

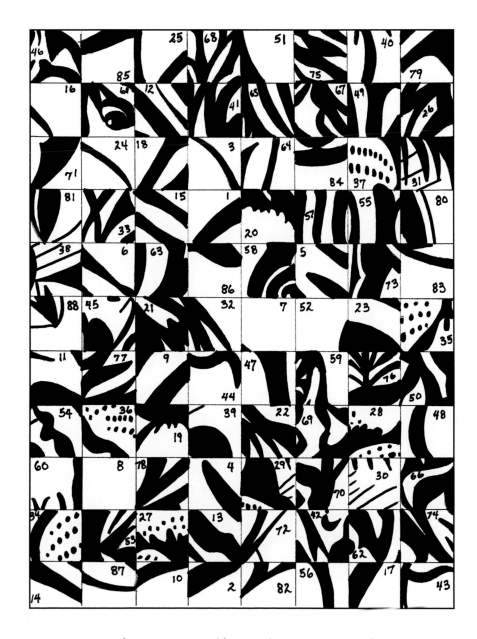

Sign up for our inspiring and free newsletter at ArtistsNetwork.com.

21

1	2	3	4	5	6	7	8
9	10	11	12	13	14	15	16
17	18	19	20	21	22	23	24
25	26	27	28	29	30	31	32
33	34	35	36	37	38	39	40
41	42	43	44	45	46	47	48
49	50	51	52	53	54	55	56
57	58	59	60	61	62	63	64
65	66	67	68	69	70	71	72
73	74	75	76	77	78	79	80
81	82	83	84	85	86	87	88

SEE ALL SUBJECT MATTER AS SHAPES

Look for the interlocking shapes within the tones and shapes of the object you are drawing. This exercise will show you how well you can draw, without even knowing what it is you are drawing!

Use a Grid to Draw From Photos

Now that you are familiar with the puzzle piece theory and the box method of drawing shapes, you are ready to draw from photographs using a grid. Everything you want to draw can be broken down into manageable pieces similar to the shapes seen in the puzzle exercise. By placing a grid over your reference photo, you will create your own puzzle to work from.

There are two different ways to grid your reference photos. The first way (and the way I prefer) is to have a color copy made of your photo. A black-and-white copy may not give you enough clarity to work from. If the photo is small, enlarge it as well. Working from small photos is the biggest mistake most students make. The bigger the photo, the easier it is to work from.

Use a ruler to apply a 1" (2.5cm) or ½" (1cm) grid directly onto the copy with a permanent marker. Use the smaller grid if there is a lot of small detail in your photo. There is less room for error in the smaller box, so little things are captured more easily.

If you do not have access to a copier and your photo is large enough to work from, you can place a grid overlay on top of the photo. Make your own grid with a clear report cover and a permanent marker, or have one printed from a computer on acetate sheets. Then simply place the premade grid over the photo and work from that.

Once you place the grid over the photo, the image becomes a puzzle and each box contains shapes. Look at everything you want to draw as just a bunch of interlocking shapes. To recreate the photo, draw a grid on your drawing paper with your pencil. Draw the lines so light you can barely see them, because they will need to be erased later. This grid should contain the same number of boxes as the one over the photo.

You can enlarge the size of your drawing by placing the smaller grid on your photo reference and making the squares larger on your drawing paper. For instance, if you use the ½" (1cm) grid on the photo and a 1" (2.5cm) grid on your paper, the image will double in size. Reduce the size of the drawing by reversing the process. As long as you are working in perfect square increments, the shapes within the boxes will be relative.

All the illustrations in this book can be drawn by placing an acetate grid over the examples.

HALF-INCH GRID

ONE-INCH GRID

Sign up for our inspiring and free newsletter at ArtistsNetwork.com.

23

Creating an Accurate Line Drawing With a Grid

These images show how using a grid can help you accurately capture the image you see in a photograph. It is important to not get overwhelmed by the details at this point. Just concentrate on the basic shapes for an accurate line drawing.

You can see how the boxes of the grid were beneficial to accurately drawing the stripes of the shirt. The shape of the body alters their direction.

The grid lines should be drawn as lightly as possible. (I make mine darker than necessary so you can see them in the book.) These lines will eventually be erased, so you don't want a "ghost" of the image left behind.

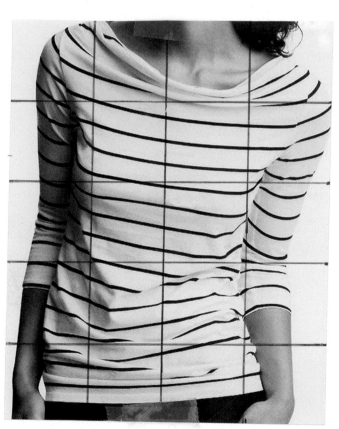

GRIDDED PHOTO
The graph over your photo should match the grid you draw on your drawing paper. Make sure you have the same number of boxes.

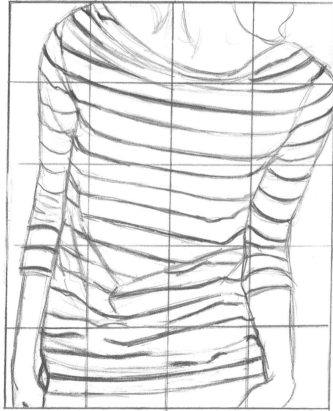

LINE DRAWING
Draw the shapes you see within each box, working one box at a time. Go slow and be as accurate as possible. Make sure everything connects properly. Your entire drawing hinges on this stage of the game.

Visit ArtistsNetwork.com/draw-realistic-clothing-and-people for bonus materials.

Creating an Accurate Line Drawing Using Segment Drawings

• • • • • • • • • • • • •

This is a method I love to use for practicing shapes, and it will help you immensely with your freehand abilities. Also, since you'll be working a small area called a *segment drawing*, you don't need to use a grid unless you want to.

Isolating an area of a photo with a viewfinder creates a segment drawing. Drawing what you see in the small opening can help in many ways. First, it isolates the subject into puzzle-like shapes, so you don't overly connect with the subject matter. It also forces you to see

only the shapes—just like a puzzle. This method gives you quick practice, rather than overwhelming you with an entire finished drawing. These small drawings can be placed in a segment drawing notebook and give you help and practice with your problem areas.

CREATE THE VIEWFINDER
Cut an opening into a piece of black construction paper with a craft knife. This creates a small frame.

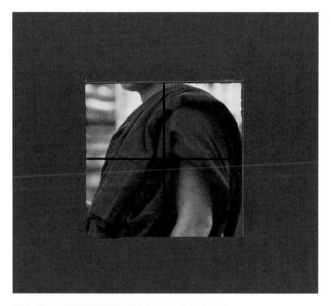

PLACE THE VIEWFINDER OVER A PHOTO
Place the viewfinder over a portion of a photograph so a small section is revealed. This will change the photo from a recognizable image to a collection of abstract shapes.

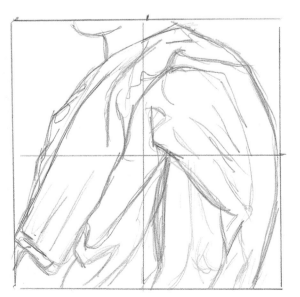

USE THE VIEWFINDER AS A TEMPLATE TO CREATE AN ACCURATE LINE DRAWING
Using the viewfinder as a template to draw the square on your paper guarantees that it is the same size. Tape down the viewfinder onto the photo, and draw an accurate line drawing of the shapes you see inside of it. Forget what the image really is and focus on just what you see. If you need more help, divide the box into a four-square grid.

Sign up for our inspiring and free newsletter at ArtistsNetwork.com.

25

Render Your Segment Drawing

• • • • • • • • • • • •

Once your accurate line drawing is complete, the grid lines should be removed from your paper using a kneaded eraser. Save this project for later, after we discuss how to properly render clothing.

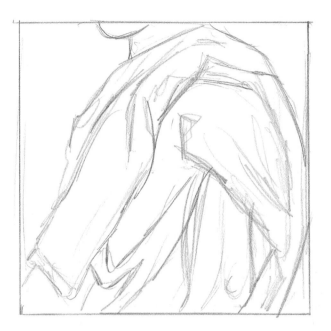

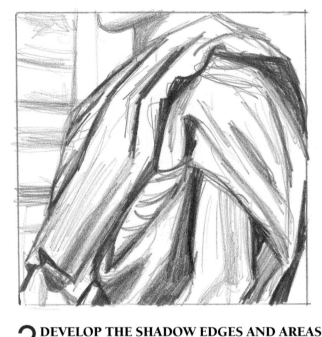

1 FILL IN THE DARKS

Always fill in the darkest areas first. Dark creates the look of light in your drawing and helps you establish your edges.

2 DEVELOP THE SHADOW EDGES AND AREAS OF REFLECTED LIGHT

Study to see where the five elements of shading are found. The shadow edges will help create the illusion of curves and raised areas.

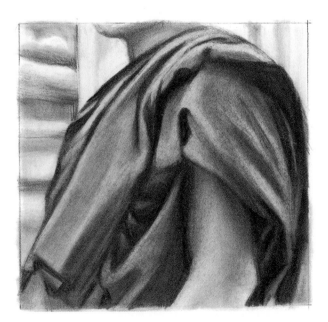

3 BLEND FOR REALISM

Blend your tones with a tortillion to create your half-tones. Fade them gently into your highlight areas.

It is the blending of the tones that makes things look dimensional. Use a kneaded eraser to lift the highlights on the raised areas of the fabric.

Visit ArtistsNetwork.com/draw-realistic-clothing-and-people for bonus materials.

Segment Drawing Notebook

· · · · · · · · · · · ·

I always recommend to my students that they create a segment drawing notebook. Below are examples from the pages of mine. To create these small drawings, I made a viewfinder with a 2" (5cm) opening in it. Then I went through photos and magazines looking for interesting subjects to draw.

For your notebook, select images that will challenge you. If you have particular trouble areas, this is a good way to practice those things without becoming overwhelmed by a big finished piece of art. It will give you valuable experience in a short amount of time.

You can see how I used a variety of subjects in my segment drawings. Each one gave me the practice I needed for perfecting certain elements. While a few helped me better understand folds and fabric, the others gave me practice drawing different parts of the body.

Be creative: Allow the viewfinder to home in on certain areas and make them appear less recognizable. That way you are forced to study just the shapes and tones.

To make the notebook look neater, I draw dark outlines around the drawings, or use graphic tape, which can be found at local art stores or on the Internet.

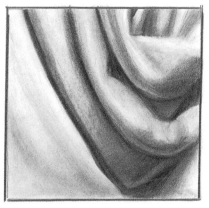
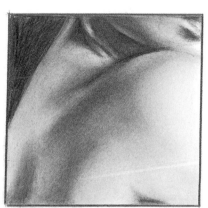
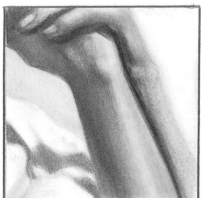
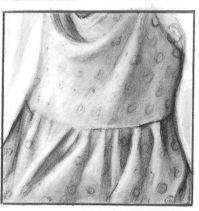

THINGS TO REMEMBER

- Find a segment drawing that would look good as a large, finished piece. Many of my favorite pieces of art are cropped versions of the original image.
- Apply the five elements of shading to everything you draw.
- Use the five-box value scale to judge the depth of your tones. Compare everything to black or white.
- Keep your blending smooth and gradual.
- Always use your tortillion at an angle to keep the tip from collapsing.
- Look for the basic underlying shapes in everything you draw.
- Look for dark against light and light against dark.
- Always think of lifting as drawing in reverse.
- Anything with an outline around it will appear flat and cartoon-like.
- A cube's flat surfaces will capture light differently than a rounded object.
- Anything with a lip, an edge or a rim will have reflected light along those edges.
- Look in magazines for photos similar to those in this chapter.

Sign up for our inspiring and free newsletter at ArtistsNetwork.com.

27

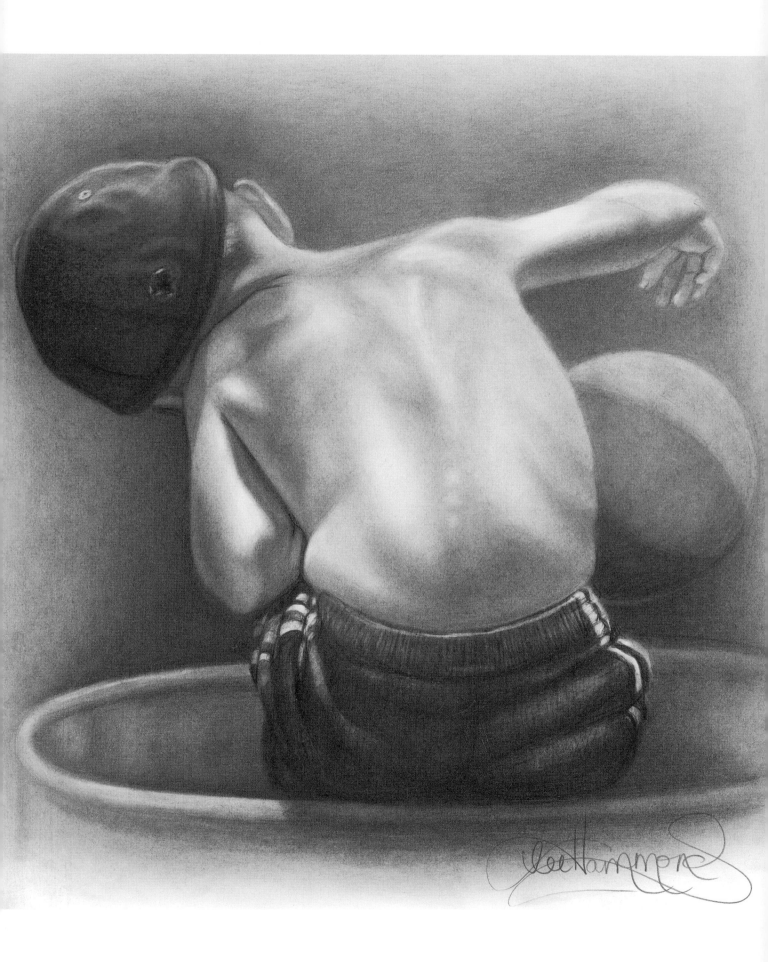

Drawing the Human Form

Before you can draw beautiful clothing and unusual fabrics, you must first learn to draw the body. The fabric is affected by the shape of the body underneath it, so you are actually drawing two things at the same time.

The body is made up of many shapes and contours. The bones and muscles under the skin create these shapes. Just like you have to understand the human form to draw clothing, you have to understand anatomy to draw the human form. These contours are created through the use of gentle shading and allowing dark to create the light.

Anatomy is quite complex. Rather than educating you here on all of the names of the muscles and bones, I am going to simplify it by showing you what to look for as an artist. You can go into much more detail on your own (and I highly recommend that you do), with further study from wonderful books such as *Grey's Anatomy* and other medical literature. But for now, we will stick to the basics and give you some artistic practice.

This chapter is designed to show you two things. First, it will show you the bones and muscles of the human form. Second, it will show you how to see the basic shapes in all of these forms. These two things are key to drawing anatomy with any degree of realism.

By looking at this drawing of my grandson, you can see all of the roundness of the muscles that were created with smooth blending. Notice that the bone structure of his spine and all of the raised areas of his body are illuminated with gentle lighting. It is the lighting that makes the body appear illuminated, and it is the capturing of subtle contours like this that will make your drawings look real and photographic.

A Drawing of Colin
11" × 14" (28cm x 36cm)
Graphite on smooth bristol

Sign up for our inspiring and free newsletter at ArtistsNetwork.com.

29

Anatomy

· · · · · · · · · · · ·

While it is not important for an artist to know the name of every bone in the body, we should at least know where the bones and muscles are and what they look like. After all, it is the bone structure that gives our bodies their framework.

As we advance, you will learn how to draw believable bodies in a variety of poses. But we have to start with the skeleton and, if you compare the drawing of the man to the one of the skeleton, you can clearly see where his shape is coming from. It is important to

understand the role of both the bones and the muscles. Only then will you also be able to capture the realistic look of the clothing.

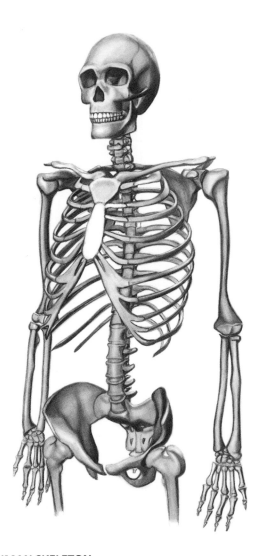

THE HUMAN SKELETON
Hard bones are the foundation for the human form.

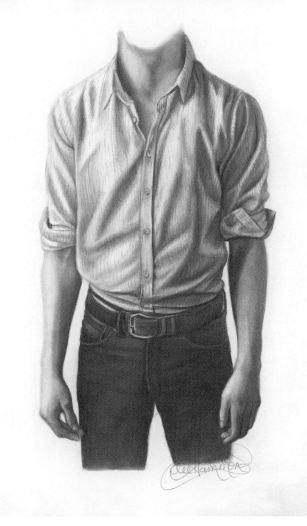

THE HUMAN FORM
Body shapes are the foundation for clothing.

Visit ArtistsNetwork.com/draw-realistic-clothing-and-people for bonus materials.

Basic Shapes in Arms

• • • • • • • • • • • •

These examples show you how the basic shapes of the sphere and the cylinder can be seen within the arm. You must see these basic shapes as the core of your subject to fully depict the three-dimensional look of the arm.

The length of the arm is captured using a long cylinder. The roundness of the shoulder, elbow joint and wrist is captured with the sphere.

By looking at the rendered version of the arm, you can see the form and

rounded thickness of the arm being created through the use of shading. The obvious shadow edge, combined with the use of reflected light, give this the illusion of a three-dimensional object.

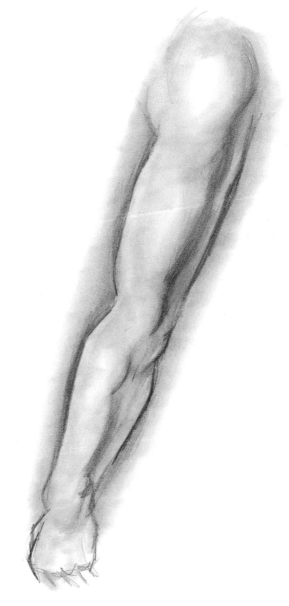

BASIC SHAPES
The basic shapes of the sphere and the cylinder make up the shape of an arm.

BLENDING AND SHADING
Blending and shading create the realism and capture the three-dimensional form.

Sign up for our inspiring and free newsletter at ArtistsNetwork.com.

31

Anatomy of Arms

• • • • • • • • • • • •

Here is the anatomy of the arm. The interior shape of the bones is the framework for the other shapes. I have labeled the bones for you, but knowing their names is not important to your art—simply knowing they are there is, however.

Whenever you are drawing the body, remember what it is you are actually looking at, and why the shapes appear the way they do.

LEE'S LESSONS

While pure observation and careful studying of a subject is critical for a realistic artist, knowledge of why something looks the way it does is important, too. Why does something look rounded in some areas and flat in others? Why does a certain part of the body seem to look angular while others appear very round?

A. Clavicle (collarbone)

B. Scapula (angel wing)

C. Humerus (long bone of the upper arm)

D. Elbow (funny bone)

E. Radius (one of the bones of the forearm)

F. Ulna (second bone of the forearm)

G. Wrist (made up of many bones)

BONES OF THE ARM

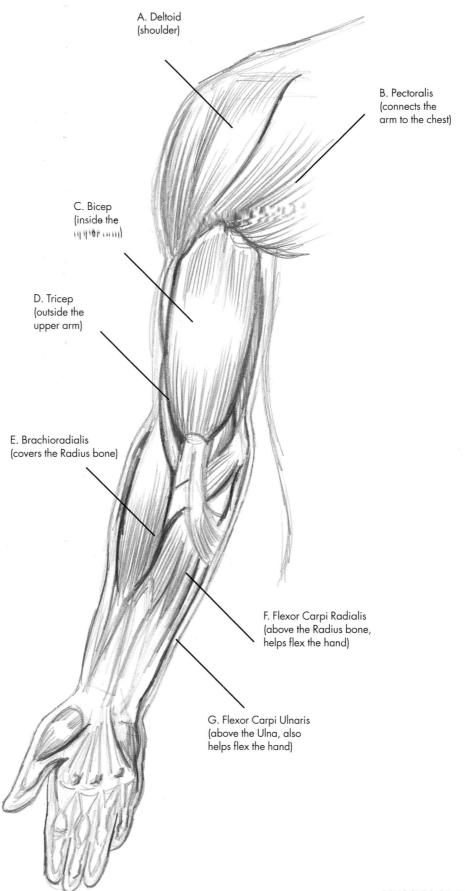

A. Deltoid
(shoulder)

B. Pectoralis
(connects the
arm to the chest)

C. Bicep
(inside the
upper arm)

D. Tricep
(outside the
upper arm)

E. Brachioradialis
(covers the Radius bone)

F. Flexor Carpi Radialis
(above the Radius bone,
helps flex the hand)

G. Flexor Carpi Ulnaris
(above the Ulna, also
helps flex the hand)

MUSCLES OF THE ARM

Sign up for our inspiring and free newsletter at ArtistsNetwork.com.

33

Drawing the Male Arm

· · · · · · · · · · ·

The male arm often shows more muscle than the female arm. Use this exercise as practice for drawing a male arm, and let the grid help you draw the shapes of the muscles. The muscles lie on top of the bones and give our bodies rounded, curved shapes. Again, names are not important, but seeing how muscles create contour is.

1 CREATE THE LINE DRAWING
This is the foundation of your drawing. Use a grid for accuracy.

LEE'S LESSONS

If you need to, lift some light out with a kneaded eraser. When "lifting" light, never use a dabbing motion. Always remember that lifting light is actually adding the light back in. It is a way of drawing, so use a stroking approach, just like you would if you were drawing it in with a pencil.

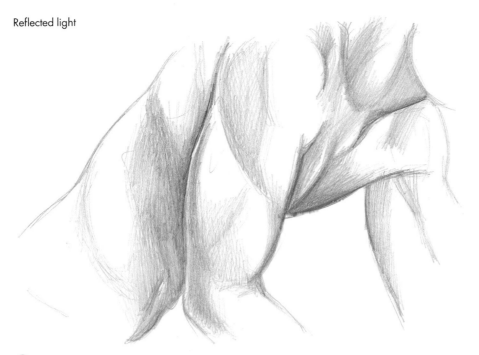

2 BUILD THE TONES

Using your pencil, add tone to capture the shadow areas on the skin. Build the tones gradually, for this will need to be blended out. (Very firm, dark pencil lines are hard to hide.)

Be sure to leave areas for the reflected light. It is always seen next to a shadow edge. This is what creates the illusion of a curved surface.

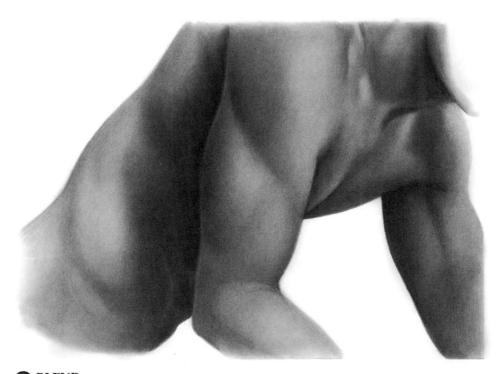

3 BLEND

Blend out the tones with a tortillion or stump. Look at how smooth and gradual the blending is, and how the subtle contours of the body have been created with the five elements of shading. Refer back to the sphere exercise and you will see the similarities.

Sign up for our inspiring and free newsletter at ArtistsNetwork.com.

35

Knee and Arm Segment

• • • • • • • • • • • • •

This segment drawing will help you practice drawing curved areas of the body. By cropping the pose into a segment drawing, the body has been turned into patterns of light and dark shapes. This makes it easier to draw since it becomes less recognizable according to our memory. I used a larger grid for this drawing, which I divided into quarters. Feel free to use more boxes if it helps you see the shapes more accurately.

1 USE A GRID
Use this grid to help you capture the shapes—notice that it is not made up of perfect squares. Make the grid on your paper 4" × 5½" (10cm × 14cm), with squares that are 2" × 2¾" (5cm × 7cm). Create an accurate line drawing that looks like the example. When you are happy with the accuracy of your shapes, carefully remove the grid lines from your paper using a kneaded eraser.

2 APPLY THE TONES
Apply the five elements of shading with your pencil to create roundness and form. Carefully study the contours, looking for the patterns of the light and dark shapes.

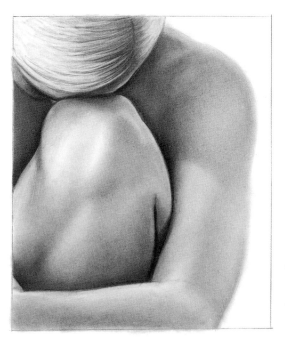

LEE'S LESSONS

Do not push hard on the stump or tortillion. While many think this will aid with the blending, it actually roughs up the paper and makes it appear blotchy.

3 BLEND THE TONES
Blend the tones with a stump or tortillion until they are smooth. Reapply dark tones if they lighten up with the blending, and lift the light with a kneaded eraser. Remember, this step may take multiple applications and repeated blending.

Visit ArtistsNetwork.com/draw-realistic-clothing-and-people for bonus materials.

Female Arm Pose

• • • • • • • • • • • •

While this book is not about portraiture, I included the face here to make the drawing more interesting. Refer to my book *How to Draw Lifelike Portraits from Photographs* for more information on drawing a face.

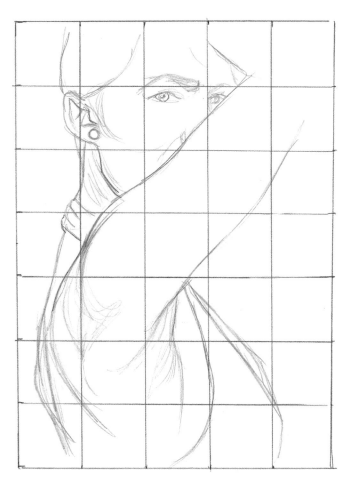

1 USE A GRID
Use a grid of 1" (2.5cm) squares to capture an accurate line drawing. This one is 5" × 8" (13cm × 20cm). When you are sure of the accuracy, carefully remove the grid lines with a kneaded eraser.

2 APPLY THE TONES
You can clearly see that the light is coming from the right side, so the shadows are on the left. Apply the darkest tones first—use them to create the roundness and form. Study the muscles and see how they affect the shape of her arm and back.

Sign up for our inspiring and free newsletter at ArtistsNetwork.com.

37

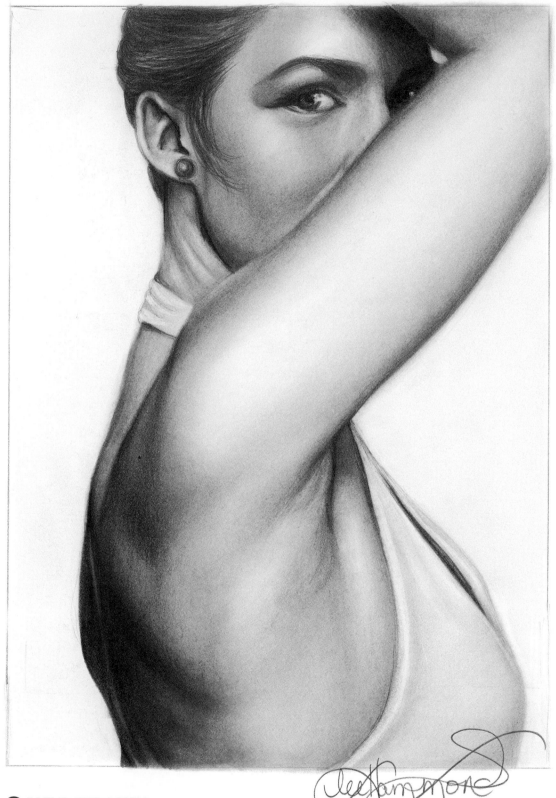

3 BLEND THE TONES

Blend to smooth the drawing and make the tones look gradual. Use a kneaded eraser to gently lift subtle highlights to create necessary highlighting on the muscles.

Basic Shapes in Legs

The leg is broken up into multiple cylinders. The five elements of shading create the subtle contours of the muscles under the skin.

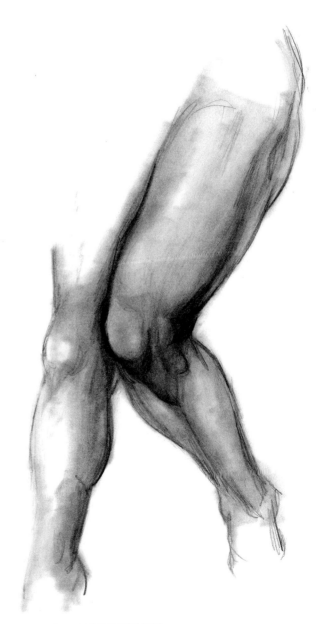

PRACTICE DRAWING CYLINDERS

BLEND FOR MUSCLE SHAPES
This quick rendering I did from an Old Master's drawing shows how the muscle shapes are created using the basic shapes as a guide.

Sign up for our inspiring and free newsletter at ArtistsNetwork.com.

39

Anatomy of Legs

Drawing legs can be more complicated than drawing arms. Legs are longer and larger, and often the muscles are more obvious. Study these examples for the placement and role bones and muscles play in the leg's shape.

The ankles are not made up of separate bones. What you see protruding are the ends of the tibia and fibula. The anklebone on the outside of your leg appears lower, while the anklebone on the inside appears higher.

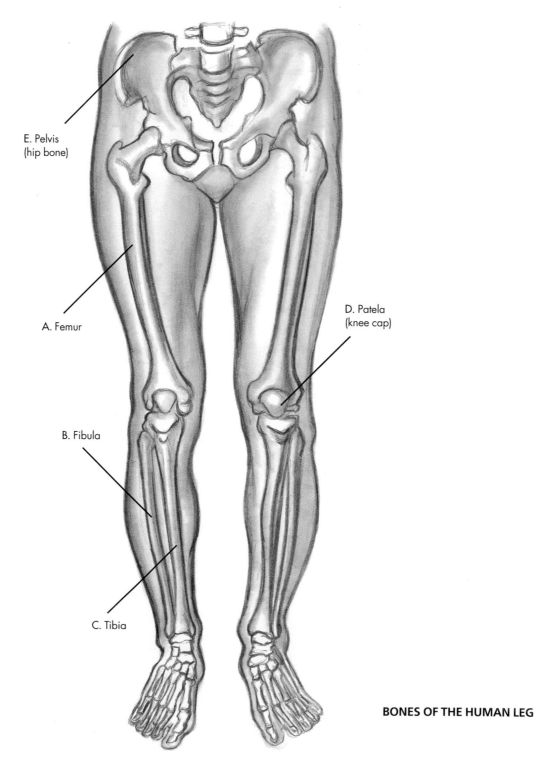

E. Pelvis
(hip bone)

A. Femur

B. Fibula

C. Tibia

D. Patela
(knee cap)

BONES OF THE HUMAN LEG

Visit ArtistsNetwork.com/draw-realistic-clothing-and-people for bonus materials.

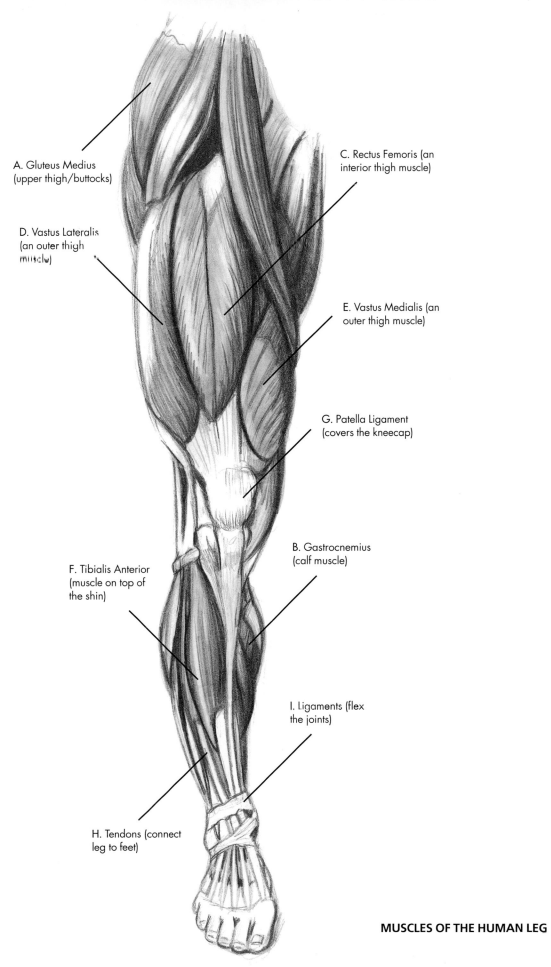

A. Gluteus Medius (upper thigh/buttocks)

C. Rectus Femoris (an interior thigh muscle)

D. Vastus Lateralis (an outer thigh muscle)

E. Vastus Medialis (an outer thigh muscle)

G. Patella Ligament (covers the kneecap)

B. Gastrocnemius (calf muscle)

F. Tibialis Anterior (muscle on top of the shin)

I. Ligaments (flex the joints)

H. Tendons (connect leg to feet)

MUSCLES OF THE HUMAN LEG

Sign up for our inspiring and free newsletter at ArtistsNetwork.com.

41

Knee and Arm Segment

• • • • • • • • • • • •

You are now dealing with four appendages that are all overlapping.
This creates many shadows and edges of reflected light.

1 USE A GRID
The grid method will help you create accurate shapes. Look at all of the overlapping areas in this drawing. Draw what you see, one box at a time. Remove the grid when you're sure of your accuracy.

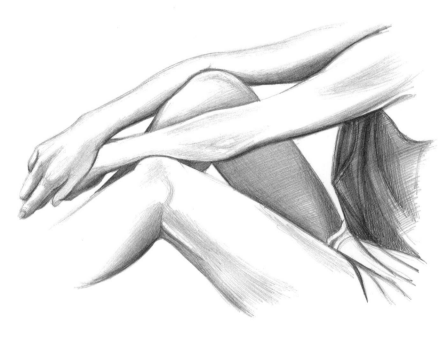

2 APPLY THE TONES
Apply the dark areas first to help create the areas of light. The darkest areas are seen where surfaces overlap and where the cast shadows are. Since the light is coming from above, all the shadows are along the bottom edge of the limbs. Shadows should also appear where the body is blocking the light, on the back leg and chest.

LEE'S LESSONS

Hard edges are created when two planes or sides come together, or when things overlap. Do not confuse this with outlining—you are using a line to separate two surfaces. A hard line is seen anytime you have two or more surfaces overlapping or touching.

To draw these hard lines without it appearing as an outline, look at the line you have drawn and study the two surfaces it separates. Decide where the dark of that line belongs. (It will belong to one of the surfaces.) Use blending to soften the look of the line, and gradually take the shading into the surface to which it belongs. Now you have created an edge, not an outline. You have actually created the light edge of one surface by making the reflected light stand out against the darker surface next to it. Remember: Dark creates light!

3 BLEND

Look at where things overlap and are creating hard edges—you will then find reflected light as well.

Study the roundness of the form and create it with gradual blending. These gentle curves are called *soft edges*. Because all of these areas are very long, blend lengthwise into the light areas. For instance, start at the lower edge of the arms and legs where it is darkest, and blend up into the light like a value scale, going horizontally. You cannot blend into it vertically without losing the smoothness.

Sign up for our inspiring and free newsletter at ArtistsNetwork.com.

43

Basic Shapes in the Neck, Shoulders and Chest

· · · · · · · · · · ·

As you saw with the arms and legs, the cylinder is one of the most important basic shapes in human anatomy. Our neck, while not as long as the arm or leg, is very clearly a cylinder.

In both of these drawings, you can see the shape of the cylinder within the neck. The larynx and muscles of the neck create this cylindrical shape. While the Adam's apple is more obvious in males, it is still a part of the female anatomy. Unless your subject is extremely young, or overweight, this bone structure can always be seen in the neck. Making the neck too smooth will make it appear unrealistic. Always look for the subtle contours.

In the male neck, the larynx and Adam's apple can clearly be seen.

The female neck is smoother, but the bone structure should still be seen.

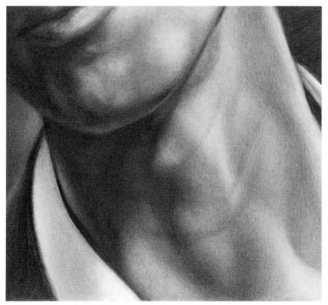

The neck is clearly a cylinder.

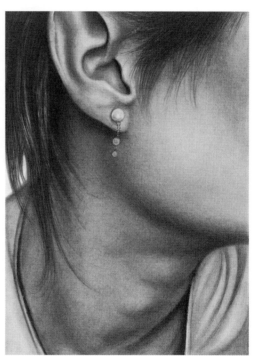

Look for the cylinder in both male and female necks.

Anatomy of the Neck

• • • • • • • • • • •

This is what the inside of the throat area of the neck looks like. The larynx is the hard portion of the front of the neck. It is not bone, but cartilage.

You can see where the Adam's apple protrudes.

The muscles are what connect the head, neck and shoulders. Knowing where these muscles are will help you when drawing the human figure. Looking at this diagram, you can see where the neck gets its shape.

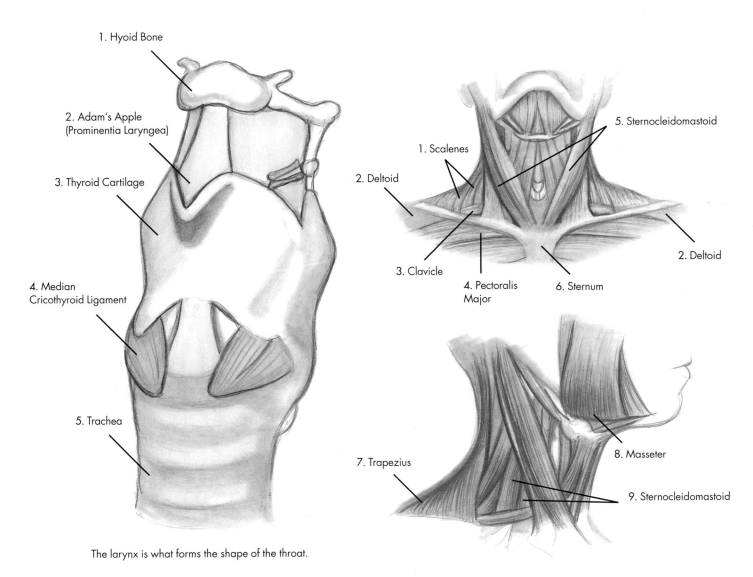

1. Hyoid Bone

2. Adam's Apple (Prominentia Laryngea)

3. Thyroid Cartilage

4. Median Cricothyroid Ligament

5. Trachea

1. Scalenes

2. Deltoid

3. Clavicle

4. Pectoralis Major

5. Sternocleidomastoid

2. Deltoid

6. Sternum

7. Trapezius

8. Masseter

9. Sternocleidomastoid

The larynx is what forms the shape of the throat.

The muscles are what give the neck and throat a smooth, curved contour.

Sign up for our inspiring and free newsletter at ArtistsNetwork.com.

45

The Chest

· · · · · · · · · · · · ·

As you can see, the body is made up of many subtle curves.

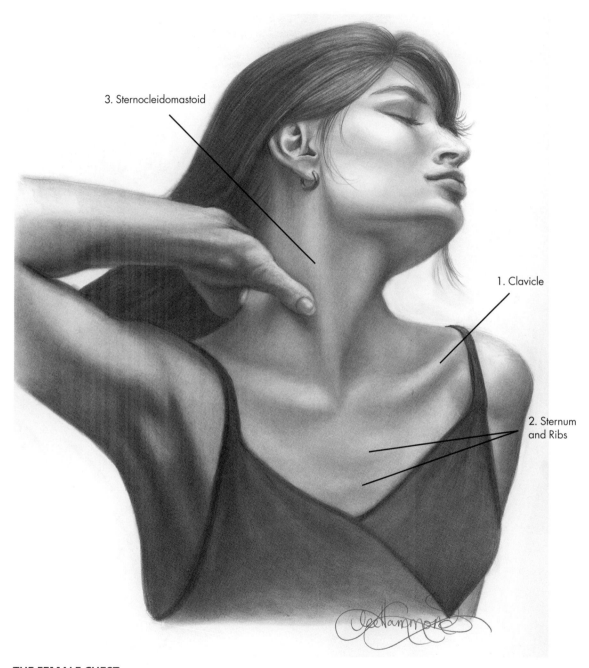

3. Sternocleidomastoid

1. Clavicle

2. Sternum and Ribs

THE FEMALE CHEST

The clavicles, also known as the collarbones, are sticking out due to the positioning of the woman's arms.

The muscles of the neck, and the bulging area of the larynx, are being described by the light source and highlighting. These tones must be gradual and smooth.

Look closely, and you can see a slight indication of the sternum and the rib cage. Use the five elements of shading to create form. Let the lighting depict the contours and the edges.

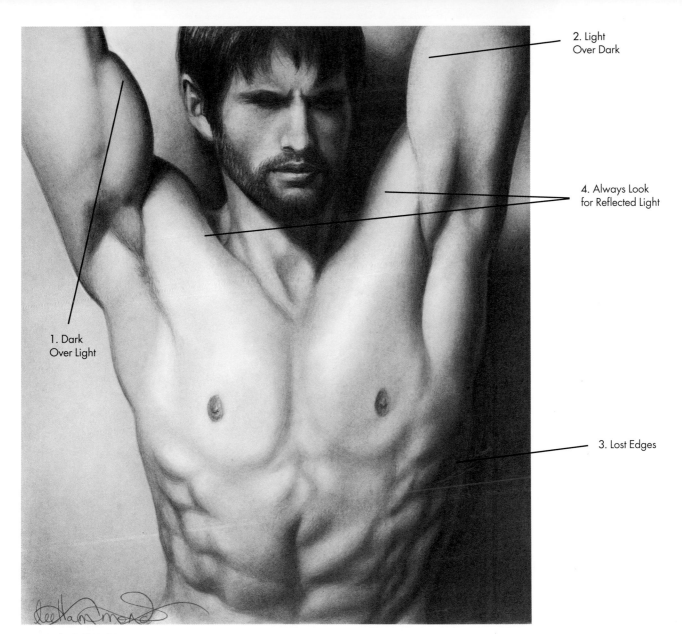

2. Light
Over Dark

4. Always Look
for Reflected Light

1. Dark
Over Light

3. Lost Edges

THE MALE CHEST

Here, the anatomy is not as subtle. This muscular male is made up of repeated sphere exercises. Look for the sphere in all of these curves, and discover how the five elements of shading were used to create the roundness of his form.

You can always tell experienced artists by the way they use the lighting to create their edges.

LEE'S LESSONS

Realism is achieved through knowing how to use lighting to create three different types of edges. In the Old Masters' artworks, they used the background to help illuminate the look of their subjects.

Dark Over Light: Where the figure appears dark along the edge, the background is lighter.

Light Over Dark: Where the figure has a light edge, the background is very dark.

Lost Edges: Where the subject goes into shadow, and the edges of the subject seem to disappear into the darkness of the background.

Sign up for our inspiring and free newsletter at ArtistsNetwork.com.

47

Gesture Drawing the Figure

Gesture drawing is a type of drawing that is done quickly and loosely, using continuous lines. Using quick, circular pencil strokes, the overall shapes of the body are quickly captured—showing how the body is moving. Doing these quick studies is great practice for seeing proportions and angles.

After the gesture drawing is done, you can analyze the basic shapes. This helps you see the dimension and all of the angles important to the pose. Looking at this illustration, you can clearly see all of the cylinders that make up the human body.

I did this drawing out of a book about the Old Masters. It is here that we capture the movement and overall shape of the body. It's also where you work through all of the problems of lighting and shading, and perfect the essence of form.

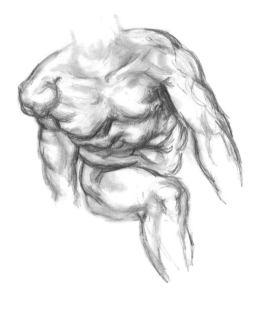

CONTINUOUS LINE
Gesture drawing is done using continuous lines and quick, circular pencil strokes. It captures shape and movement.

BASIC SHAPES
Breaking down the pose into basic shapes helps you to see the dimensions of the human form.

ROUGH RENDERING
Rough rendering helps the artist see the effects of light on a subject. This is where the five elements of shading are thought through.

Visit ArtistsNetwork.com/draw-realistic-clothing-and-people for bonus materials.

Foreshortening

.

The term *foreshortening* is affected visually by perspective. When drawing, our minds have a tendency to want to correct the image so more details can show.

I recommend looking in sports magazines, where there are a lot of action shots. Sports photography provides a wealth of material to practice

drawing foreshortened views, particularly with arms and legs.

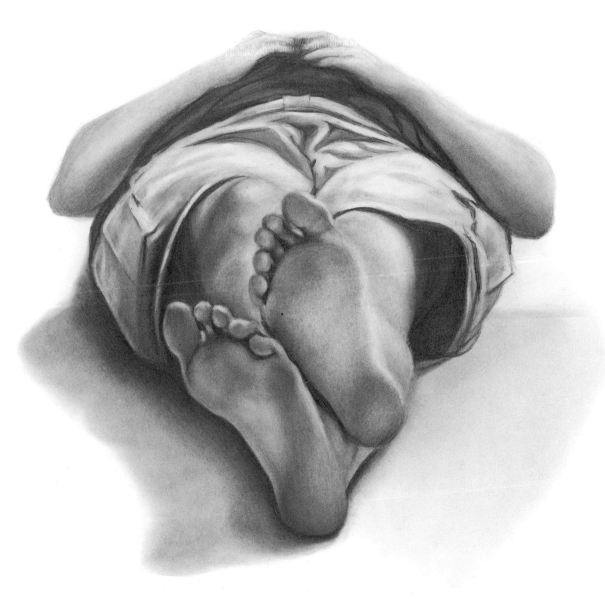

EXTREME FORESHORTENING
This extreme view of foreshortening shows how the entire length of the body is blocked from view. What you do see is the bottom of the feet and the length of the arms; everything else is diminished due to foreshortened perspective. The entire length of the body is gone, as well as the upper body itself. This is a difficult phenomenon to capture without a lot of practice, so give it the time it demands.

Sign up for our inspiring and free newsletter at ArtistsNetwork.com.

49

Gesture Drawing for Foreshortening

• • • • • • • • • • • •

Gesture drawing can also help you work through the visual problems of foreshortening. You can see in this pose how the length of the legs seems to be distorted. Quick, circular strokes can help with the proportions and connecting everything.

Blocking in the form with basic shapes shows the dimension and where the curves of the body should be. This is where the angles of the body need to be studied as well—we often make the human form a lot rounder than it really is. See it geometrically, and look for angles!

In this rendered version, you can see how important light is in depicting foreshortening. With the light illuminating the back, it looks closer to the viewer. It also appears larger than the rest of the body. The legs, on the other hand, are in shadow and are extending away from the viewer. The length of them seems to be shorter because of perspective and tone—foreshortening makes long things look distorted.

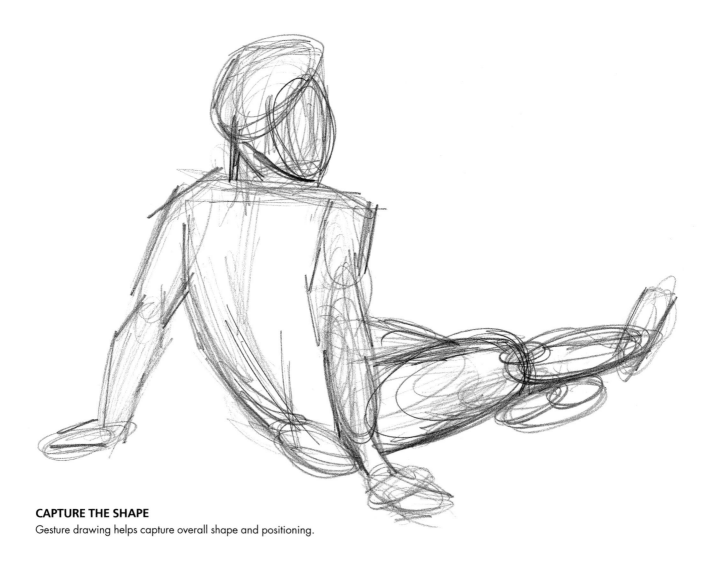

CAPTURE THE SHAPE
Gesture drawing helps capture overall shape and positioning.

Visit ArtistsNetwork.com/draw-realistic-clothing-and-people for bonus materials.

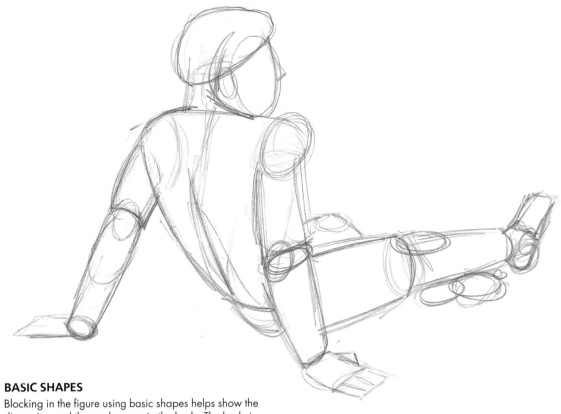

BASIC SHAPES

Blocking in the figure using basic shapes helps show the dimension and the angles seen in the body. The body is more angular than we think.

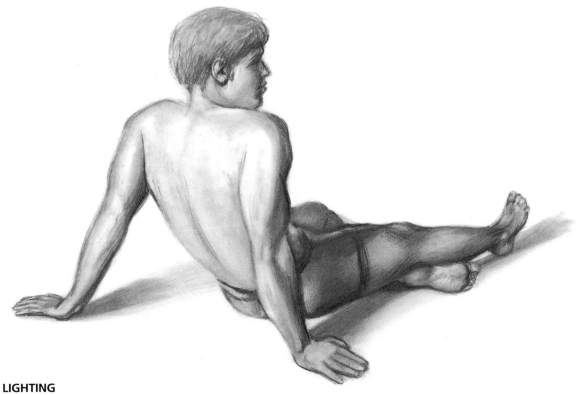

LIGHTING

The pose of this foreshortened figure makes the legs look smaller and shorter than usual.

Sign up for our inspiring and free newsletter at ArtistsNetwork.com.

51

Body Pose

• • • • • • • • • • • • •

Use this exercise for creating an entire body pose. The cropped view of this girl places all of the focus onto the curves and lighting of the arms and legs.

1 INSERT THE GRID LINES
Use a grid to help you create an accurate line drawing.

2 TAKE OUT THE GRID LINES
Once you're sure of your accuracy, carefully remove your grid lines from your drawing paper. With your pencil, apply the darkest areas first. This is seen where two areas overlap or touch one another.

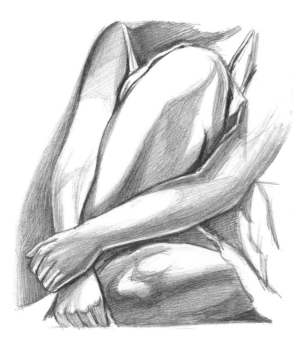

3 MAP OUT THE TONES
Continue adding the tones to the drawing with your pencil. This is like mapping out your areas into light, medium and dark. Apply your lines like a value scale, going from dark to light, so they are easy to blend.

Visit ArtistsNetwork.com/draw-realistic-clothing-and-people for bonus materials.

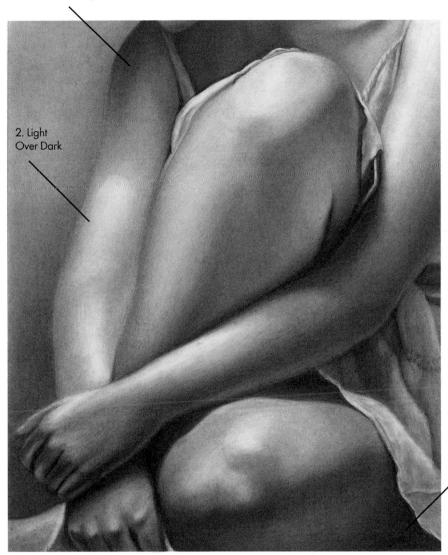

1. Dark Over Light

2. Light Over Dark

3. Lost Edges

4 BLEND
Blending is what makes this drawing look so real. Be sure that your tones are smooth and gradual. Remember the value scale!

Use the blending technique to soften the tones of the drawing. Allow the tones to fade gradually into one another for a smooth-looking contour. Use the dark background to create the light-over-dark and dark-over-light illusion, as well as the look of lost edges.

THINGS TO REMEMBER

- Use your segment drawing notebook and your viewfinder to practice drawing different body parts, without overwhelming yourself with the entire body.
- Study the effects of light on the body, and how it illuminates all of the subtle contours and curves. Practice using the Dark Over Light, and Light Over Dark theories, and use tone in the background to help describe your edges.
- Go through magazines and look for different poses to draw. Look for outdoor lighting, and how bright sunlight affects the look of the body.

- Don't forget to try some quick sketch practice and gesture drawing as well just to see the basic shapes.
- You cannot simply read about it or analyze it all day long—you must draw, even if you make mistakes.

Sign up for our inspiring and free newsletter at ArtistsNetwork.com.

53

Drawing Hands & Feet

Before we go much further, we must address hands and feet. We talk about them separately because drawing hands is often an artist's nightmare. I have heard more complaining and frustration from my students about this subject than any other. I even wrote an entire book on this subject alone—it's that important.

When drawing hands, the angles are crucial. We have a tendency to draw hands way too rounded. This creates a chubby appearance, much like a baby hand.

Drawing feet is similar to drawing hands, for they contain many of the same characteristics. What makes them seem harder is that we don't look at feet as much as we look at hands. We have much better memories of hands and are not as familiar with the anatomy of feet.

Like hands, feet are also angular in their bone structure. Before you can draw a pair of feet, though, you must go back to basics and learn their anatomy.

The following chapter will clear up much of the frustration for you. It will help you see the hands and feet correctly so they look dimensional and realistic.

Study of a Young Child's Hand
8" × 8" (20cm × 20cm)
Graphite on smooth bristol

Anatomy of Hands

The hands are made up of many different bones and segments. These joints and segments are what give the hands and fingers their angular appearance. When you look at the X-ray view, you can see why they shouldn't be drawn overly rounded.

Like any other part of the body, you must learn the anatomical makeup of the hands to draw them realistically. Knowing the bones will help you understand why they look the way they do. You can see the way the bones appear under the skin.

When you look at the top of your hand, you will also see the tendons. These cover the bones and muscles, and help make the fingers and hand move.

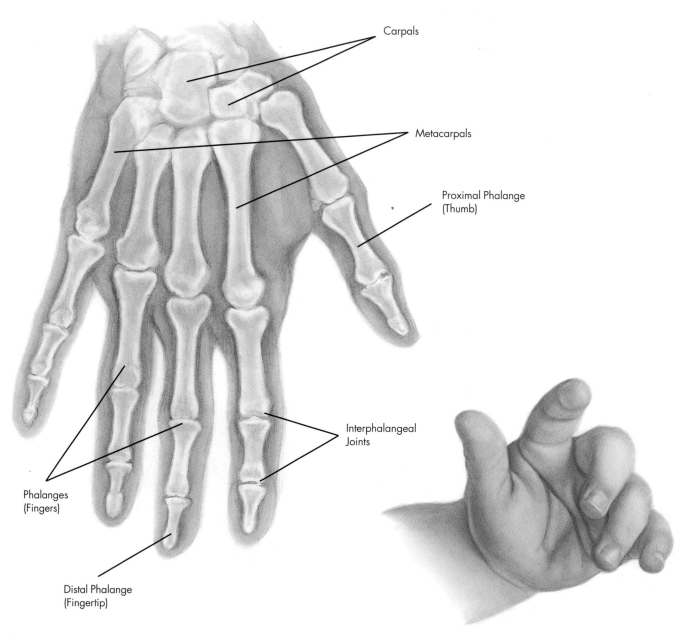

Carpals

Metacarpals

Proximal Phalange
(Thumb)

Interphalangeal
Joints

Phalanges
(Fingers)

Distal Phalange
(Fingertip)

A baby has chubby hands, but look closely and you will still see angles due to the joints.

Visit ArtistsNetwork.com/draw-realistic-clothing-and-people for bonus materials.

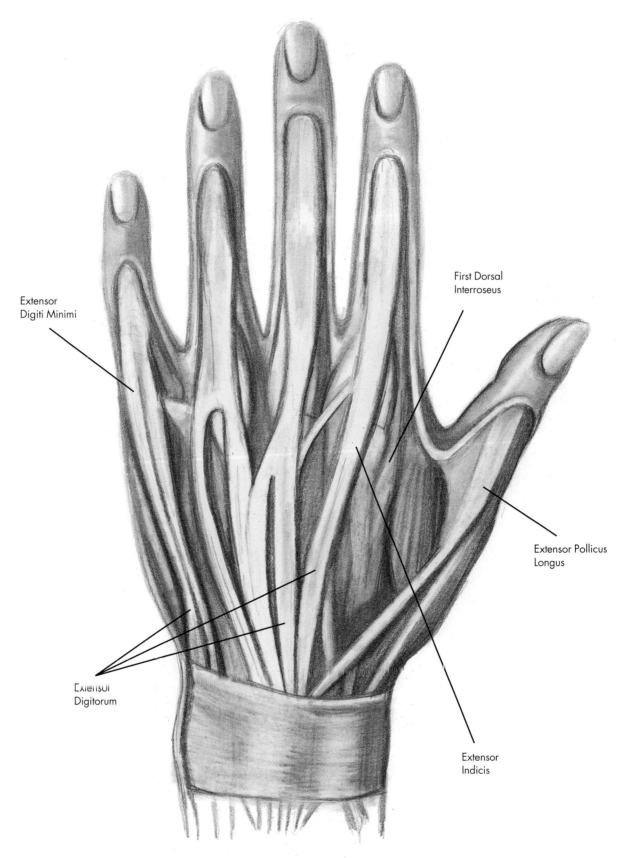

First Dorsal
Interroseus

Extensor
Digiti Minimi

Extensor Pollicus
Longus

Extensor
Digitorum

Extensor
Indicis

TENDONS OF THE HAND

The tendons of the top of the hand are what you
see under the skin.

Sign up for our inspiring and free newsletter at ArtistsNetwork.com.

57

Hands

• • • • • • • • • • • •

Use this exercise as practice for drawing hands. Use a grid to help you see the angles created by the joints of the fingers. Seeing these angles is important in order to make the hands look realistic.

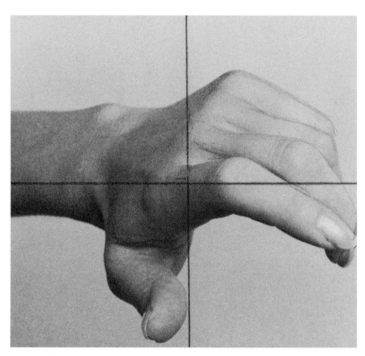

REFERENCE PHOTO
Place the grid lines directly over the reference photo to help see the hand as shapes.

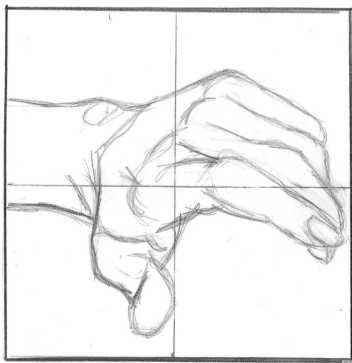

1 CREATE THE LINE DRAWING
Use the grid method to draw an accurate line drawing of a hand. Be sure to look for the straight angles within each segment of the fingers.

Visit ArtistsNetwork.com/draw-realistic-clothing-and-people for bonus materials.

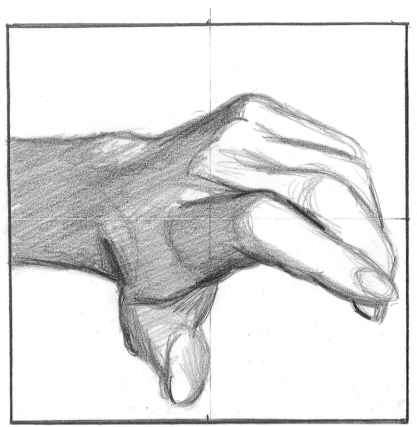

2 APPLY THE DARK AREAS

When you are sure of your accuracy, remove the grid from your drawing with a kneaded eraser. Apply the darkest areas of the drawing with your pencil. The light is coming from the upper right. Your darkest areas are underneath the index finger, and between the finger and thumb. There is a shadow on the top of the hand and down the arm.

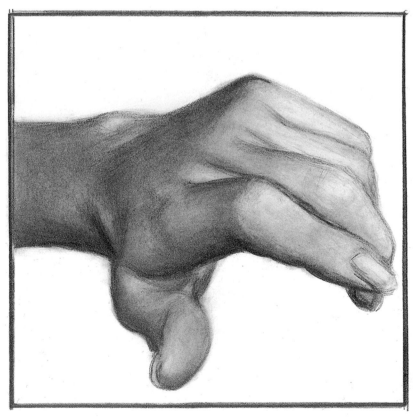

3 BLEND

Blend the tones with a tortillion to make the skin appear smooth. Use a kneaded eraser to lift subtle highlights off of the top of the fingers, the thumb and the wrist bone.

Sign up for our inspiring and free newsletter at ArtistsNetwork.com.

59

Keys to Drawing Hands

There are a few more key things to remember when drawing hands:

- The knuckles and joints divide the fingers into distinct segments to prevent the fingers from looking too rounded and rubbery.

- The hand is about the size of the face, from the chin to just above the eyebrow.
- Men's hands are boxier than females'. Female hands tend to be longer and more slender.

- Older hands show more prevalent veins, needing shading—remember highlights.

HAND ANGLES AND SIZE
This is a good study of how large the hand is compared to the rest of the body. The hand is about the same length of the neck, from the collarbone to the chin.

AGED HANDS
As you can see, all hands are different. Each person has his or her own characteristics, and much can be told about people by the looks of their hands. The veins are more prevalent, and the skin is wrinkled and creased. Drawing skin like this is very similar to drawing fabric because of the surface textures.

Drawing hands can be challenging. When drawing the clothed figure, they are an enhancement. But, if the hands are close-up, the detail should be there to help tell the story.

NOTE THE DIFFERENCES BETWEEN MALE AND FEMALE HANDS
Notice the distinct difference in the shape of the anatomy.

Foreshortened Hands

· · · · · · · · · · · ·

These quick studies make you isolate the segments of the hands, giving them a more jointed appearance. They help you see the foreshortening that appears when something is protruding toward you.

When drawing hands, do some studies like these to capture the basic shapes. This will help you to fully understand the direction of all the angles. Adding geometric shapes to the

drawing helps you see the angles of the fingers and the direction they are pointing. While parts of the fingers look like cylinders, most of the fingers are actually rectangular.

BASIC SHAPES IN HANDS
The basic shapes seen in the hands are more rectangular than rounded.

EXTREME FORESHORTENING
This example is a case of extreme foreshortening. The hand is reaching out and coming toward us. This alters the way we view the fingers. We see more of the tips and less of the length.

Sign up for our inspiring and free newsletter at ArtistsNetwork.com.

61

Hand and Shoulder

· · · · · · · · · · · · ·

The five elements of shading are extremely important here; you can clearly see the sphere exercise (shoulder), as well as the cylinder (fingers).

An important note, though: Even though you see the cylinder in these fingers, do *not* round them out as much as a true cylinder. Make them a bit more rectangular. Use the following steps as your guide.

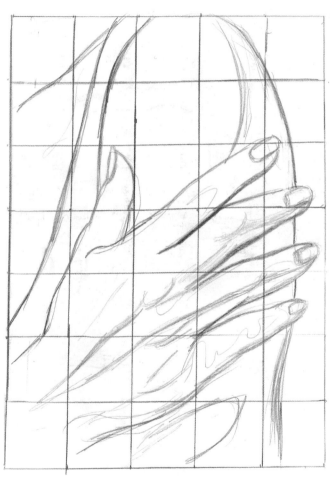

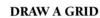 **DRAW A GRID**
Draw a grid on your paper to match the one here. Draw what you see in each box until your drawing looks like mine. When you are sure you are accurate in your line drawing, remove the grid from your paper with a kneaded eraser.

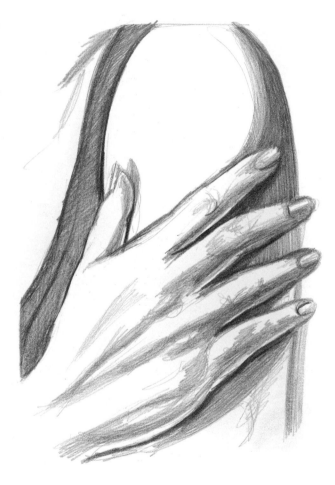

2 ADD THE TONES
With your pencil, apply the dark shadow tones. Pay particular attention to the angles seen in the fingers. Each finger has reflected light along the bottom edge. Let the shadow edges and the cast shadows create it. You can see how important the five elements of shading are here!

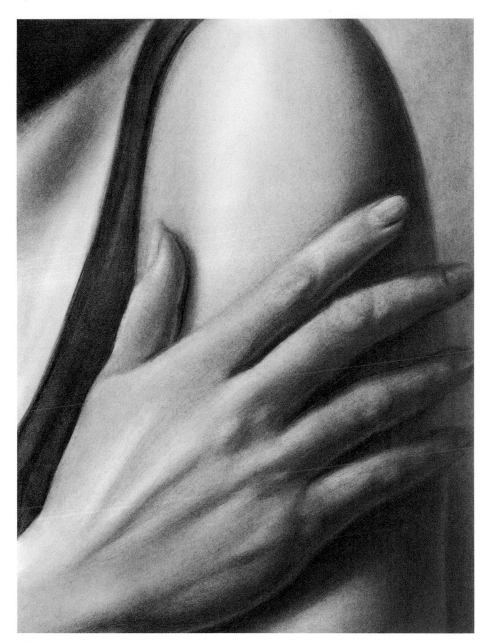

3 BLEND

Blend the tones with your tortillion to make the shading look smooth. Skin is not white, so every part of this drawing will have some shading to it.

Use your kneaded eraser to gently lift the highlights out of the drawing.

LEE'S LESSONS

Take your time. While there are basically three to four steps to drawing, there may be multiple actions required within each step. Going back and forth by adding tones, blending and lifting light is necessary to achieve a realistic end result. Devote the time necessary!

Sign up for our inspiring and free newsletter at ArtistsNetwork.com.

63

Anatomy of Feet

• • • • • • • • • • • •

The foot has many small bones that connect to the leg bones. You do not need to know the names of each one, but you must understand how they all connect and create the look of the foot.

Like the hands, the muscles and tendons affect the way the feet look. When you look at the top of your foot, it is the tendons you see. Again, knowing the names is not important; knowing they are there is.

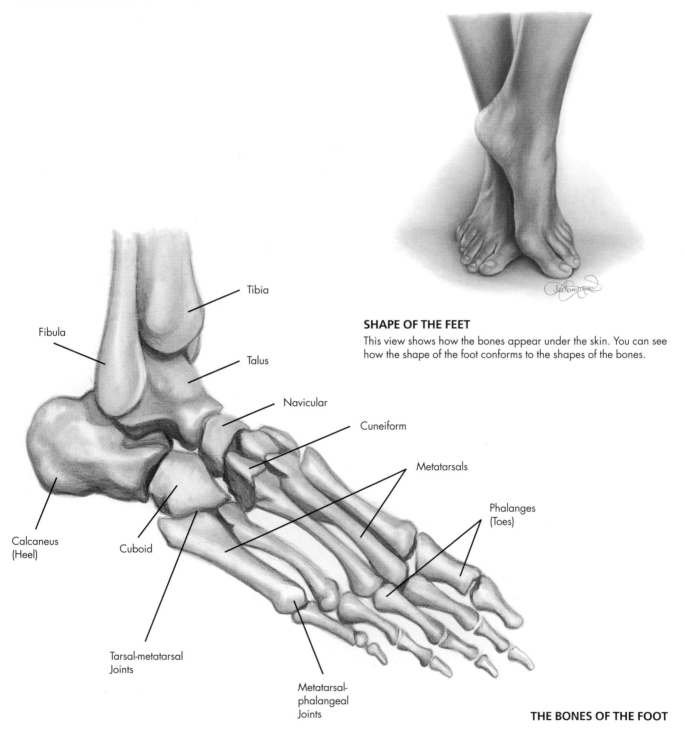

SHAPE OF THE FEET
This view shows how the bones appear under the skin. You can see how the shape of the foot conforms to the shapes of the bones.

Fibula

Tibia

Talus

Navicular

Cuneiform

Metatarsals

Phalanges (Toes)

Calcaneus (Heel)

Cuboid

Tarsal-metatarsal Joints

Metatarsal-phalangeal Joints

THE BONES OF THE FOOT

Visit ArtistsNetwork.com/draw-realistic-clothing-and-people for bonus materials.

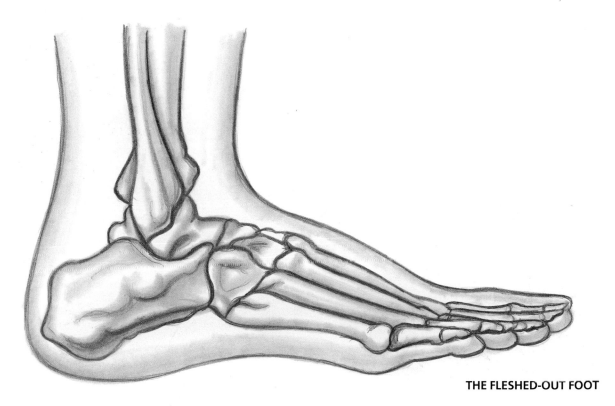

THE FLESHED-OUT FOOT

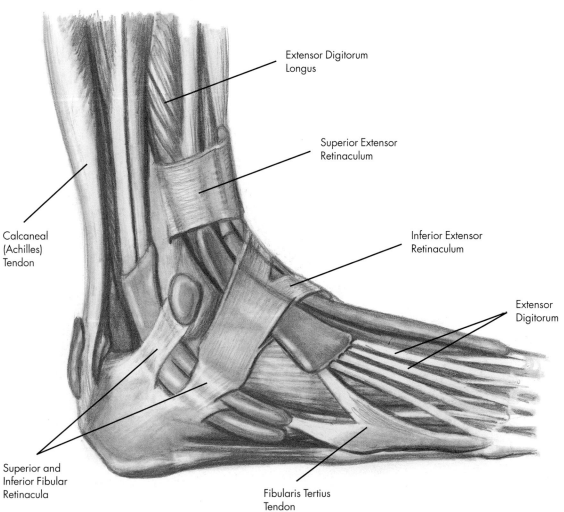

Extensor Digitorum
Longus

Superior Extensor
Retinaculum

Inferior Extensor
Retinaculum

Extensor
Digitorum

Calcaneal
(Achilles)
Tendon

Superior and
Inferior Fibular
Retinacula

Fibularis Tertius
Tendon

THE TENDONS AND MUSCLES OF THE FOOT

Sign up for our inspiring and free newsletter at ArtistsNetwork.com.

65

Keys to Drawing Feet

· · · · · · · · · · · · ·

- The ankles are not separate bones. They are actually the ends of the leg bones, which connect the foot.
- The ankle on the outside of the leg is lower and closer to the foot.

- The ankle on the inside of the leg is higher. Drawing them straight across from one another is not anatomically correct. However, the human mind

likes to balance everything to make things symmetrical.

FEET BACK VIEW
This back view of the feet shows the proper ankle placement. The outside ankle is lower than the inside. This ankle placement is very important, especially in fashion drawing.

LEE'S LESSONS
Remember, draw what you *see*, not what you *remember*. Memory can play games with you and make your drawings inaccurate.

BABY FEET
While feet are often just an enhancement for fashion or figure drawing, feet can also become a finished piece. This cute little drawing of baby feet would make a good gift or note card. The chubby quality hides the bone structure. You can tell the age just by looking at them.

Visit ArtistsNetwork.com/draw-realistic-clothing-and-people for bonus materials.

Feet

• • • • • • • • • • • •

You can see how feet accent the muscles of the legs. Use the grid method to help draw this pose of the feet and legs.

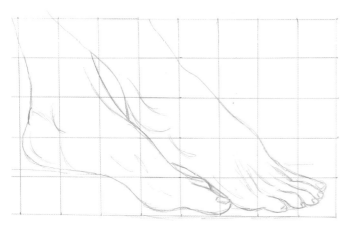

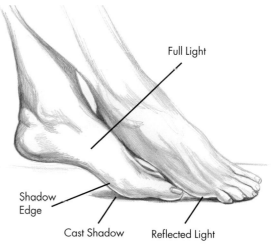

Full Light

Shadow
Edge

Cast Shadow

Reflected Light

1 DRAW A GRID

Draw a grid on your drawing paper that matches this one. Draw what you see in each box until you create an accurate line drawing. When you're sure of your accuracy, remove the grid from your paper with a kneaded eraser.

2 ADD THE TONES

Apply the dark tones with your pencil to start creating the shapes and contours of the feet and legs. Remember the five elements of shading!

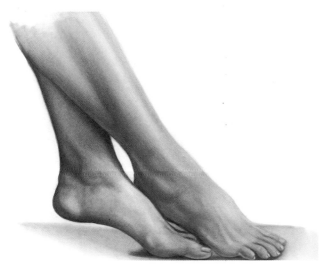

3 BLEND

This stage requires smooth blending. Refer back to the cylinder exercise. You must blend lengthwise into the light area to capture the form.

Use a kneaded eraser to gently lift the highlights in the full light areas. You can see how important the lifted light is for creating the top of the foot, showing the bones and tendons coming off of the toes.

THINGS TO REMEMBER

- When drawing the clothed figure, the feet and hands are an important aspect of the drawing. Don't be tempted to leave them out. Practice feet and hands using your segment drawing notebook, and learn the anatomy.
- Hands can add so much to the meaning of a drawing or a portrait. It can help tell a story and create a mood that would be lost if the hands were simply left out. Be a skilled artist and work through the problems. Like anything else, it takes time.
- I've seen so many students give up on the hard stuff, only to have their drawings never advance. While it is easy to draw the same old stuff, the same old way, true artists will push themselves. Don't give up! Be a greater artist by tackling the hard stuff. Do it over and over again until you get it right! You'll be glad you did.

Sign up for our inspiring and free newsletter at ArtistsNetwork.com.

67

The Five Folds of Fabric

• • • • • • • • • • •

To show you the five different folds, I have taken a striped washcloth and molded it into different shapes. Each example represents one of the folds and what it looks like. I chose the striped fabric so you can see how the shape and form will alter the way a pattern on clothing is viewed.

Edges are the most important part of drawing clothing and fabric. Without creating appropriate edges, the realistic look will be lost. I placed a cast shadow behind this washcloth so the edges of reflected light would be more obvious.

Go back to the previous page with the illustration of the scarf and you will find both of these folds within it.

Look for the five elements of shading in all of these examples. It is the use of light and shadow that makes them look realistic.

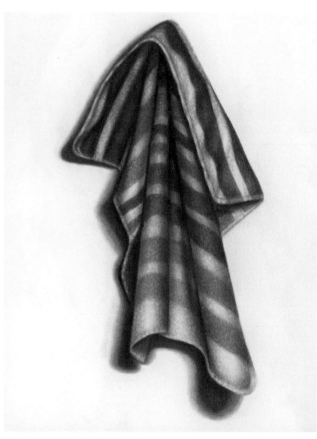

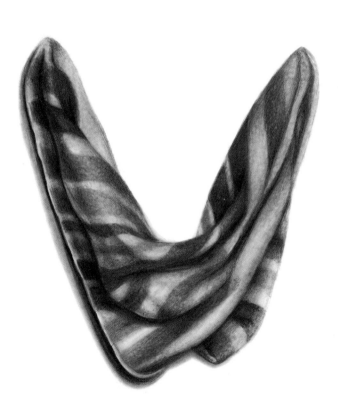

COLUMN FOLD

The most common type of fold is called a *column fold*, also known as a tubular fold. This is created when a piece of fabric is hanging from one point of suspension. The results are tube-like folds that are similar to a cone shape or a cylinder.

Note how each "tube" is created using the five elements of shading. You can see where the light is reflecting off of the raised areas. The shadow edge (or turning shadow) and the reflected light help make it look rounded.

DRAPE FOLD

The drape fold occurs when a piece of fabric is suspended by two points. The fabric hangs down in the middle, falling in on itself. Again, the five elements of shading are applied to each of the areas to depict the roundness and depth of the washcloth. Look at how the stripes go in and out of the fabric. This interruption of pattern adds to the look of realism.

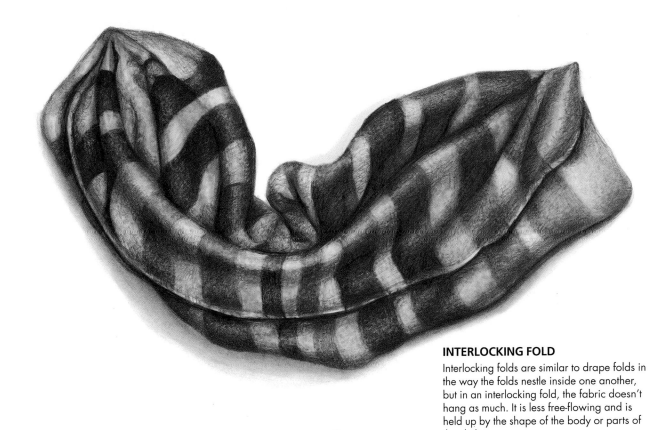

INTERLOCKING FOLD
Interlocking folds are similar to drape folds in the way the folds nestle inside one another, but in an interlocking fold, the fabric doesn't hang as much. It is less free-flowing and is held up by the shape of the body or parts of the clothing.

COIL FOLD
These folds also interlock, like the drape and interlocking fold, except they encompass the body like a tube. You will find this where fabric is wrapping around something cylindrical.

Sign up for our inspiring and free newsletter at ArtistsNetwork.com.

71

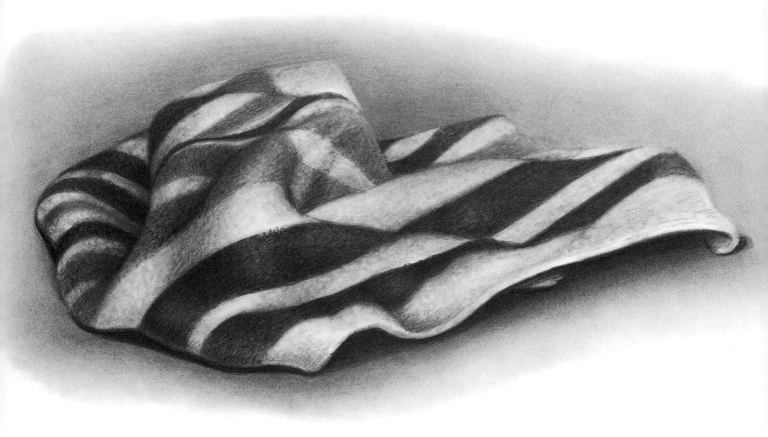

INERT FOLD

Inert folds are found when fabric is at rest. It is not hanging at all, for it is resting on a surface. In this position, it can take on many shapes and contours, so close observation is necessary. An inert fold can go from being very smooth and subtle, to highly creased and extremely complicated.

FIVE FOLDS

This drawing shows what it looks like when all five of the folds collide into one situation. You can see how important each one is to the believability of this drawing.

Let's identify where all five of the folds are. Each area of the outfit has different folds:

1. The ruched fabric encompasses the woman's body with coil or spiral folds.
2. The skirt of the dress falls down into column or tubular folds.
3. Her two arms are supporting the back of the jacket. This creates a drape fold. Most of this fold is behind her.
4. The sleeve of the jacket that appears under the collar is creating interlocking folds.
5. The area of the sleeve that is resting on her wrist is inert.

Visit ArtistsNetwork.com/draw-realistic-clothing-and-people for bonus materials.

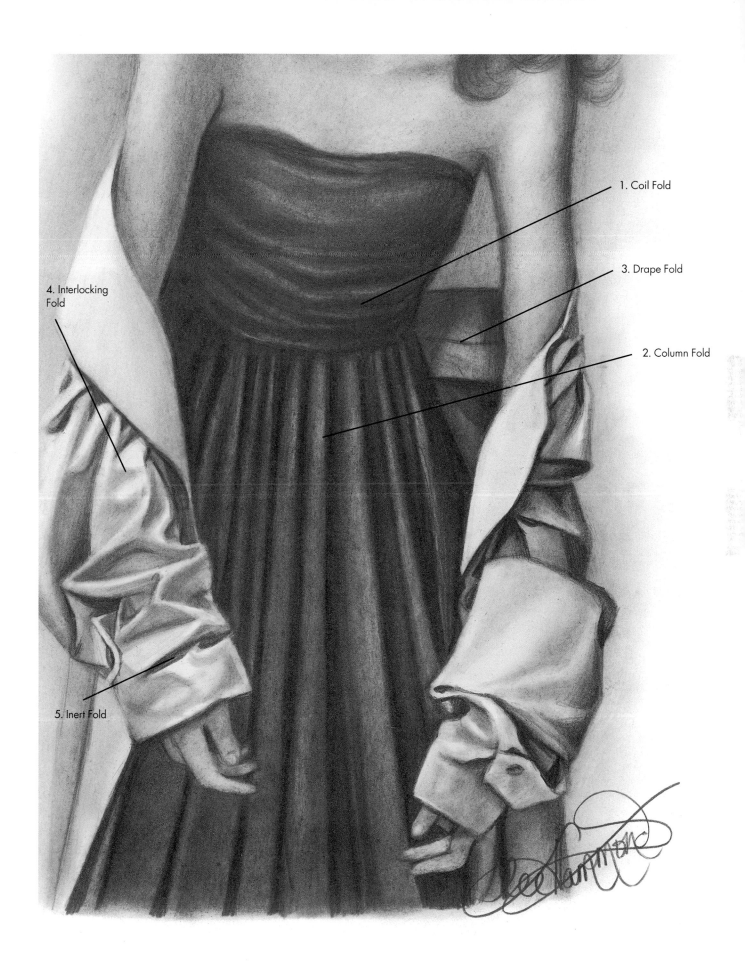

1. Coil Fold

3. Drape Fold

2. Column Fold

4. Interlocking Fold

5. Inert Fold

Sign up for our inspiring and free newsletter at ArtistsNetwork.com.

73

Column Fold

• • • • • • • • • • •

Follow along to create a column, or tubular, fold. As you can see, these folds are often found in drapes and skirts.

Each one of these tubular areas must be treated like an individual project. Each column of the fold should be seen like a cylinder or cone. Refer back to the basic shapes demonstrations to guide you.

1 CREATE THE LINE DRAWING
Create an accurate line drawing. Look at the angles created by the folds: Some are straight, while others curve and create V shapes. This is where the cone shape comes in.

2 MAKE THE PATTERNS
Create the patterns of light and dark using the five elements of shading. Study the edges of the folds and look for cast shadows, reflected light along an edge, shadow edges or turning shadows where things curve.

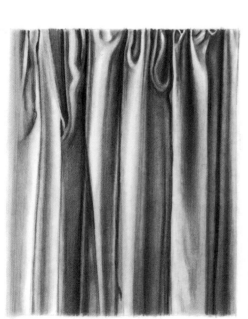

3 BLEND
Use the blending technique to smooth tones. Blend like you would a value scale, going lengthwise with the fabric. Use a kneaded eraser to lift highlights—this is what creates the realism.

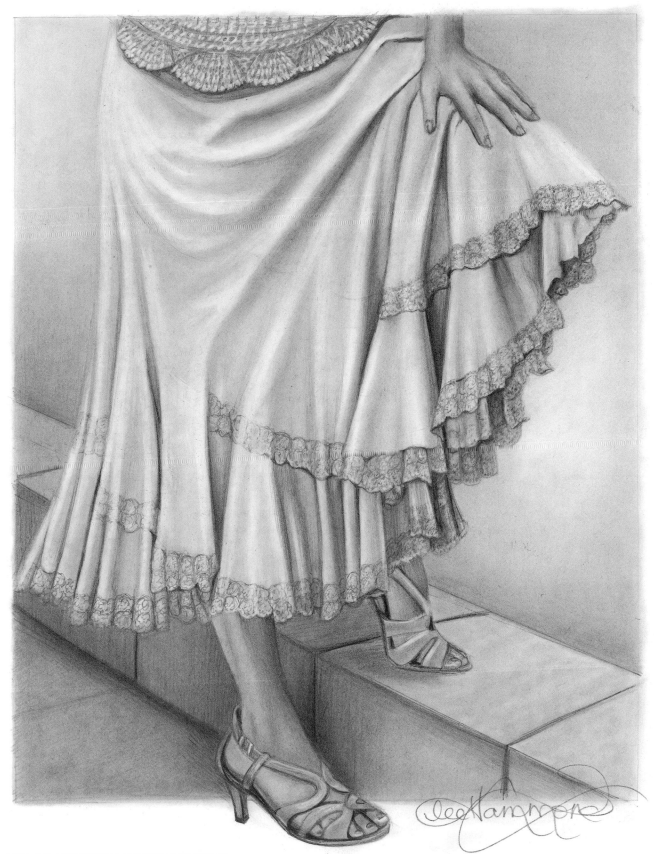

FIND THE COLUMN FOLDS IN THIS SKIRT

This skirt is made up of many column folds. Each fold looks like a
tube, cone or cylinder and it closely resembles the curtains.

Sign up for our inspiring and free newsletter at ArtistsNetwork.com.

75

Drape Fold

• • • • • • • • • • • • •

Follow along to create a drape fold, and use this segment to focus on how the fabric looks. You can see that it's being suspended by two separate points, with draping in the middle. Always look for the five elements of shading when drawing any type of fold.

1 CREATE THE LINE DRAWING
Create an accurate line drawing. This is where you must capture the folds and creases. Use a grid to help you sort it out.

2 MAKE THE PATTERNS
Carefully remove the grid from your drawing. Create the patterns of light and dark using the five elements of shading. Apply all the darkest areas first; this helps separate each of the folds. Then apply a dark background.

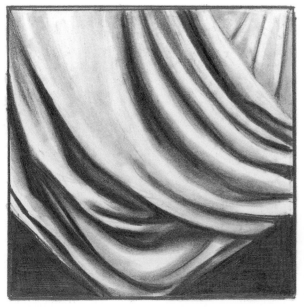

3 BLEND
Use the blending technique to smooth tones, and a kneaded eraser to lift highlights. This gives it a lot of dimension.

Visit ArtistsNetwork.com/draw-realistic-clothing-and-people for bonus materials.

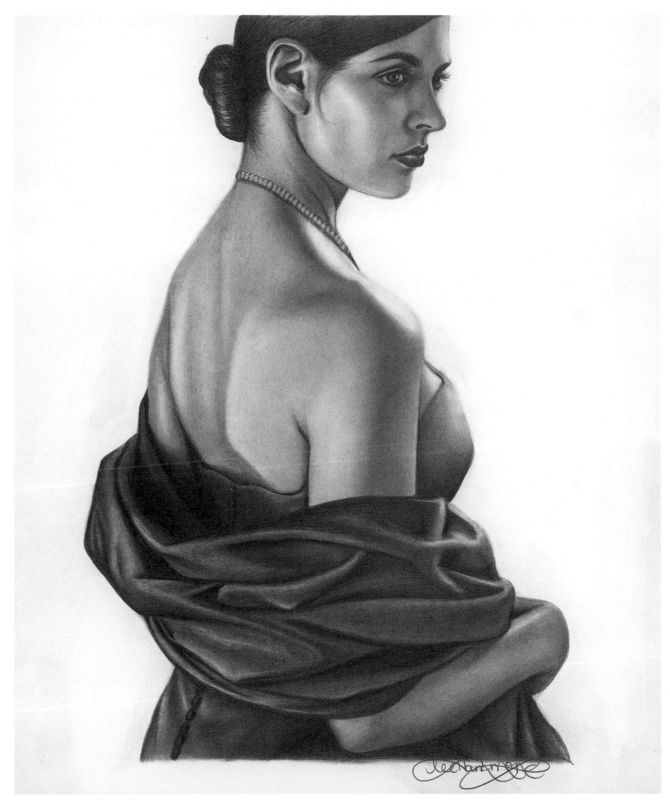

DRAPE FOLDS IN CLOTHING

Look at how the reflected light is all along the raised areas and edges of the shawl. Drape folds are seen wherever fabric is suspended from two different points. The arms are elevating this shawl from two points of suspension, making the fabric droop in the middle.

Sign up for our inspiring and free newsletter at ArtistsNetwork.com.

77

Interlocking Fold

· · · · · · · · · ·

An interlocking fold could also be classified as a coil fold, but it's not as severe—it's looser. This section shows how the fabric is folding in on itself in an interlocking fashion.

1 CREATE THE LINE DRAWING
Create an accurate line drawing. Use a grid to help map out the shapes. It looks like a puzzle.

2 MAKE THE PATTERNS
Create the patterns of light and dark using the five elements of shading. Apply the darkest areas first since there is a lot of extreme contrast in this piece.

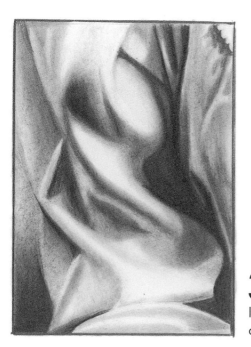

3 BLEND
Blend to smooth tones, and use a kneaded eraser to lift highlights. Pay particular attention to the shadow edges and reflected light areas.

Visit ArtistsNetwork.com/draw-realistic-clothing-and-people for bonus materials.

This is an example of where you would see an interlocking fold in clothing. As you can see by this cowl-neck sweater, the folds rest inside one another, much like the drape fold. You can also see some inert folds where the fabric is being suspended in the middle. It is very common to see more than one type of fold within a single piece of fabric.

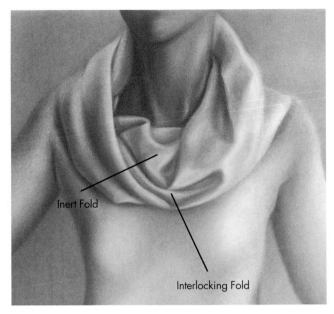

INTERLOCKING FOLD IN CLOTHING

Here's an interlocking fold in a cowl-neck sweater. It's not uncommon to see multiple types of folds within one garment.

In this cowl-neck sweater, the folds rest inside one another, much like the drape fold. You can also see some inert folds where the fabric is being suspended in the middle.

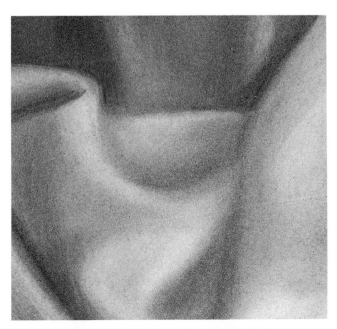

AN INERT FOLD WITHIN AN INTERLOCKING FOLD

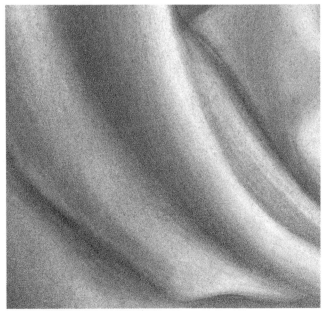

INTERLOCKING FOLD UP CLOSE

Sign up for our inspiring and free newsletter at ArtistsNetwork.com.

79

Coil Fold

• • • • • • • • • • • •

Coil folds are very common because of the cylindrical shape of the body. Follow along to create a coil or spiral fold.

1 CREATE THE LINE DRAWING
Create an accurate line drawing. Show where the fabric is overlapping and creating the coils or spirals.

2 MAKE THE PATTERNS
Create the patterns of light and dark using the five elements of shading. Use a dark background to create the light edges of the fabric.

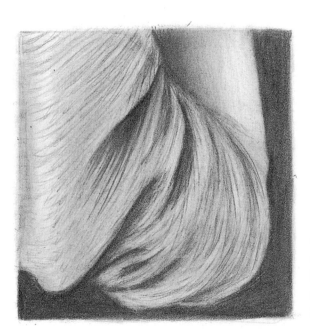

LEE'S LESSONS
Not all drawings will be large. It is important to learn how to draw small, which is actually harder to do. Give yourself practice drawing all different sizes.

3 BLEND
Use the blending technique to smooth tones, and a kneaded eraser to lift highlights. The use of little, light lines create the texture of the sweater. Texture always goes in last, after the form has been achieved.

These are two examples of where you would see a coil fold in a piece of clothing.

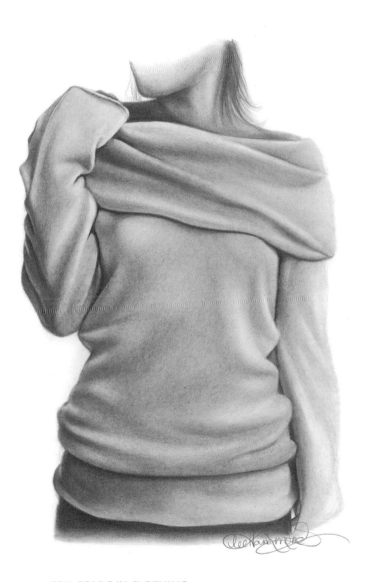

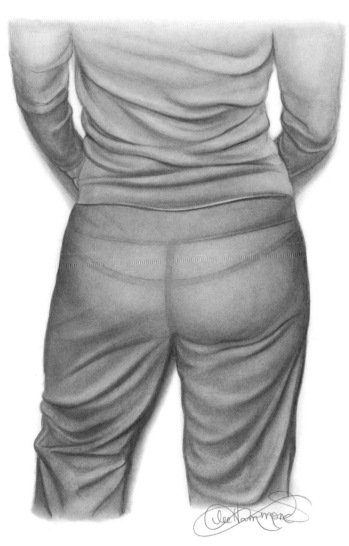

COIL FOLDS IN CLOTHING

Notice this sweater is circling around and encompassing the roundness of the body. You can see the fabric creating coil folds where it is wrapping around the arms and the body's trunk. The cowl of the sweater is also creating a coil fold around the neck and shoulders.

Interlocking folds are often seen within a coil fold. You can see this quite well in the cowl—it's where the fabric bunches up and nestles the folds inside one another.

Sign up for our inspiring and free newsletter at ArtistsNetwork.com.

81

Inert Fold

• • • • • • • • • • • •

This inert fold is in a shiny fabric, satin, which makes the lights and the darks really stand out. Due to the shininess of the fabric, the reflected light is very bright.

1 CREATE THE LINE DRAWING
Create an accurate line drawing. Capture the shapes of the lights and darks. You can see many V and Y shapes.

2 MAKE THE PATTERNS
Add the tones to the patterns of light and dark, using the five elements of shading. Create the darkest areas first to create the look of recessed areas.

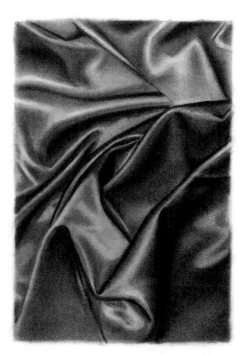

3 BLEND
Smooth out the tones, and use a kneaded eraser to lift highlights. The highlights are quite bright here due to the shininess of the satin.

Visit ArtistsNetwork.com/draw-realistic-clothing-and-people for bonus materials.

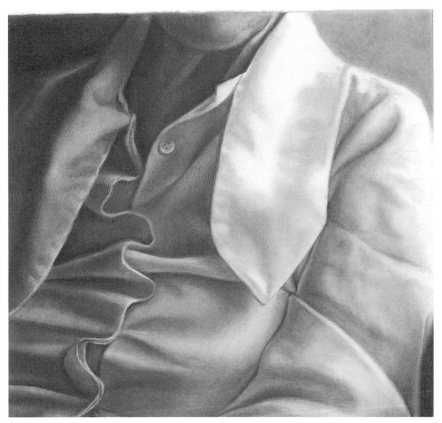

INERT FOLDS IN CLOTHING

Inert folds happen when clothing is getting wrinkled and is no longer lying flat.

Notice subtle inert folds in the collar and sleeve. It is where the fabric is no longer lying flat, but is lightly raised and irregular.

You can also see other folds here. The front of the shirt is a combination of column folds, and the sleeve has coil and interlocking folds.

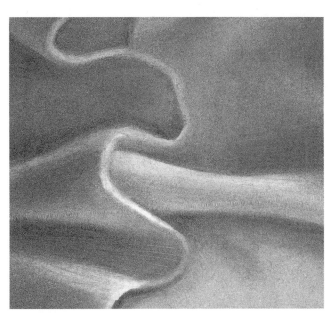

The front placket of the shirt is being forced into a series of column, or tubular, folds.

The sleeve is made up of coil and interlocking folds.

Sign up for our inspiring and free newsletter at ArtistsNetwork.com.

83

All Five Folds Together

· · · · · · · · · · ·

When you are drawing fabric and clothing, the folds will not always be as obvious as the ones in the previous examples. At times, it will be hard to identify which ones are actually present. This example of blue jeans shows how different types of folds can be hidden within one article of clothing.

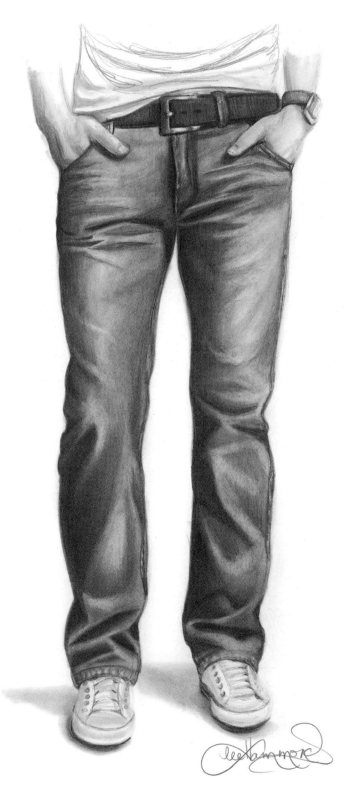

Visit ArtistsNetwork.com/draw-realistic-clothing-and-people for bonus materials.

The T-shirt here is creating drape folds. They are caused by the way the shirt is being pulled on the sides, and then released in the middle.

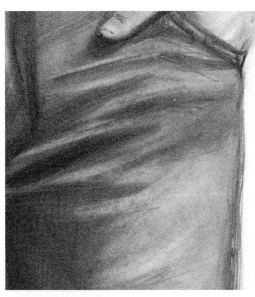

The stress being placed on the pocket of the blue jeans is creating interlocking folds. They are small, but they are nestling inside one another.

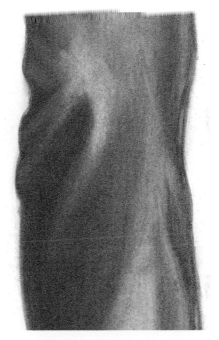

The fabric of this pant leg is being pulled down by the weight of the fabric. The front then becomes a tubular or column fold.

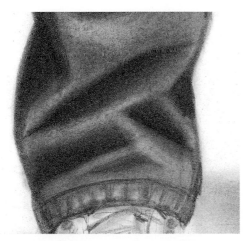

The fabric here is resting or breaking onto the foot. This puts the fabric at rest, creating an inert fold.

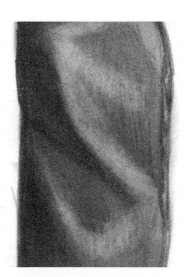

This pant leg is being twisted around the leg. Because of the twisting, it wraps around the leg, causing a spiral or coil fold.

Sign up for our inspiring and free newsletter at ArtistsNetwork.com.

85

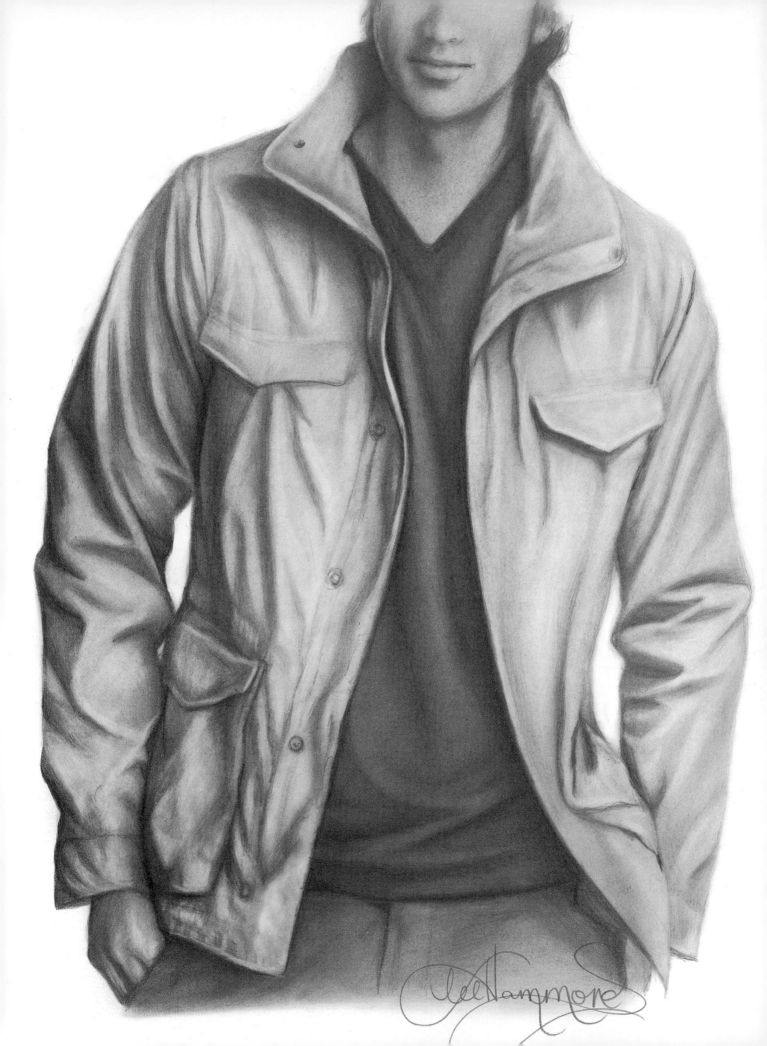

Drawing Clothing

Now that we have covered the basics for drawing fabrics and folds, we can put it all together and draw actual clothing.

Fabric, as we have seen, is highly affected by lighting. That's why drawing from statuary is so beneficial. This chapter will give you practice drawing many types and the details of fabric, such as patterns, textures and transparency. We'll also cover various lighting situations. There are thousands of different types of fabric, and each one holds unique characteristics. Some are very smooth and shiny, like satin. Some are highly textured and coarse, like a knitted sweater. Some are transparent in nature, so what is underneath shows through. All of these different situations require skill when capturing them in a drawing.

Follow along for some fun exercises that will introduce you to the ever-changing, wonderful world of drawing clothing!

Many subtle characteristics of actual fabric are shown in this example. The gentle wrinkling of the fabric is highlighted by the light source. These subtle qualities are what make fabric look realistic in a drawing. Leaving something too smooth makes it look flat and unrealistic. Quality work is always described in the small details.

A Windbreaker
11" × 14" (28cm × 36cm)
Graphite on smooth bristol

Sign up for our inspiring and free newsletter at ArtistsNetwork.com.

87

Statues

· · · · · · · · · · · ·

You may wonder why I am including pages on drawing sculpture in a book about drawing clothing and people. The fact is, drawing from statues is wonderful for drawing practice.

Look at all of the values of tone this drawing has. It was of great value to me for studying the effects of light and dark on creases and folds. Because they are so rigid and chiseled, the edges of the fabric stand out more than an actual piece of soft clothing. I often go to garden shops and look at the outdoor statues. I usually take my camera and capture them for reference photos to use in class. With the bright sunlight on them, they become a wealth of practice work for an artist.

The Good Samaritan

FOLDS AND FORM ARE EASY TO SEE IN STATUES
Not only did it give me practice drawing the human form, it was great for drawing fabric and folds.

Look at all of the creases and folds in this example. All five of the folds are represented here. Look at the small section close-ups to see where they are.

Column Folds
(Tubular)

Coil Folds
(Spiral)

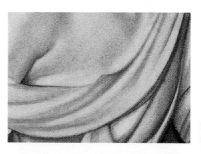

Drape
Folds

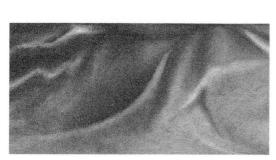

Inert Folds

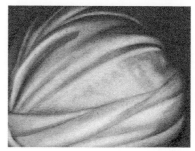

Interlocking
Folds

Visit ArtistsNetwork.com/draw-realistic-clothing-and-people for bonus materials.

Draped Statue

· · · · · · · · · · · · ·

This is a close-up of a draped figure. You can see how complicated it can be with its many interlocking folds. Go slow when drawing your lines, and rely heavily on the grid system to aid you. Draw one box at a time, which will help you sort out all of the folds.

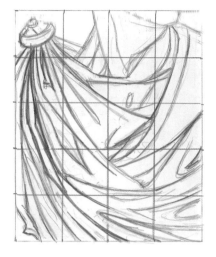

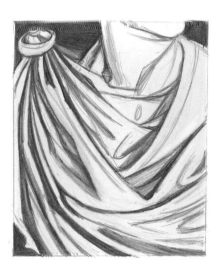

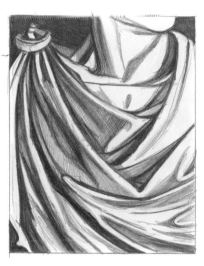

1 CREATE THE LINE DRAWING
Use the grid method to map out an accurate line drawing. Draw what you see in each of these squares. This amount of line work can get confusing, so go slow.

2 ADD THE TONES
Remove the grid lines from the finished line drawing. Add the darkest tones to establish the recessed areas. This will help separate the folds, making it less confusing.

3 SHADE
Create dimension using the five elements of shading. Creating the shadow edges makes the drapery look three-dimensional. Leave the areas of reflected light alone for now.

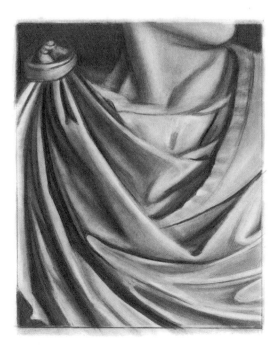

4 BLEND
Use the blending technique to smooth tones. Blend into the reflected light areas. Use a kneaded eraser to lift the highlights back out. This makes them look more reflective.

Sign up for our inspiring and free newsletter at ArtistsNetwork.com.

89

Colored Statue

• • • • • • • • • • •

The outdoor setting for the statue creates many deep cast shadows. Draw in the dark areas first to help create the look of the light source. Contrast such as this is what makes a drawing dramatic and appealing.

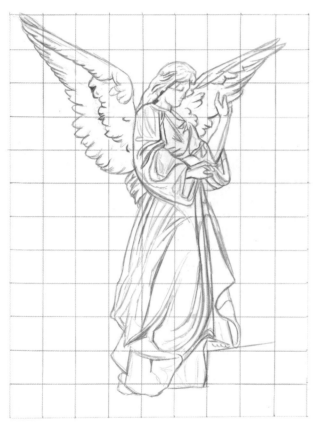

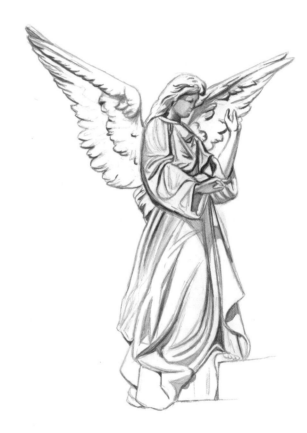

1 CREATE THE LINE DRAWING

Use a grid to capture the many shapes of this angel statue. Make your squares at least 1" (2.5cm); smaller than that, and it will be too hard to draw accurately.

2 REMOVE THE GRID

When you are sure of the accuracy of your drawing, carefully remove the grid from your drawing paper with a kneaded eraser. Apply the darkest areas of the drawing first to establish the cast shadows as well as the highlight areas.

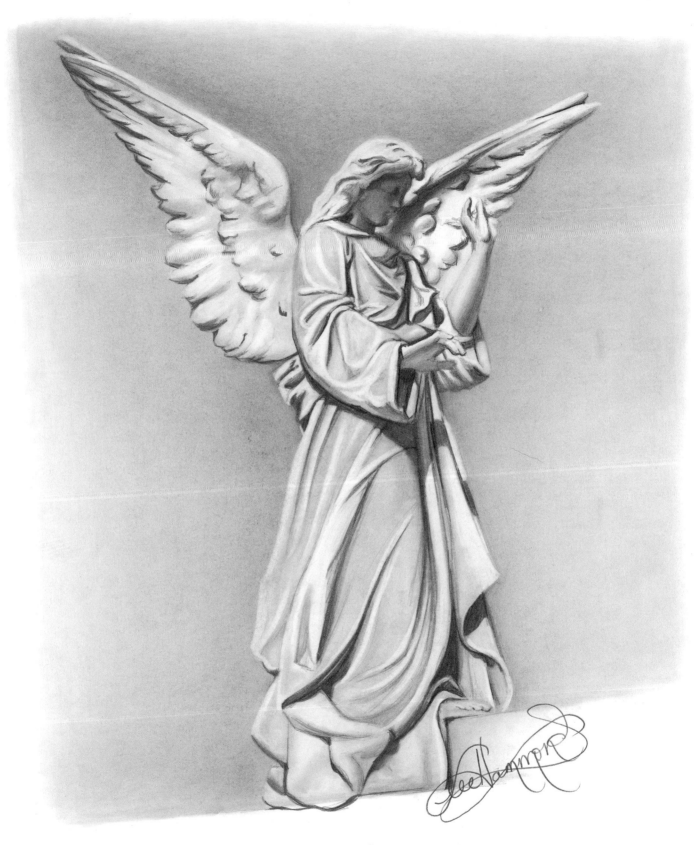

**Drawing of an
Outdoor Angel**
11" × 14" (28cm × 36cm)
Graphite on smooth bristol

3 FINISH

Make the statue look more realistic with an application of light shading into the background. Because the background is a light gray, it makes both the light areas and the dark areas of the drawing appear enhanced.

Sign up for our inspiring and free newsletter at ArtistsNetwork.com.

91

Movement and Clothing

• • • • • • • • • • • •

The movement of the body, and the darkness of the background, enhance this flowing, transparent fabric. It takes practice and good observation to create a drawing like this.

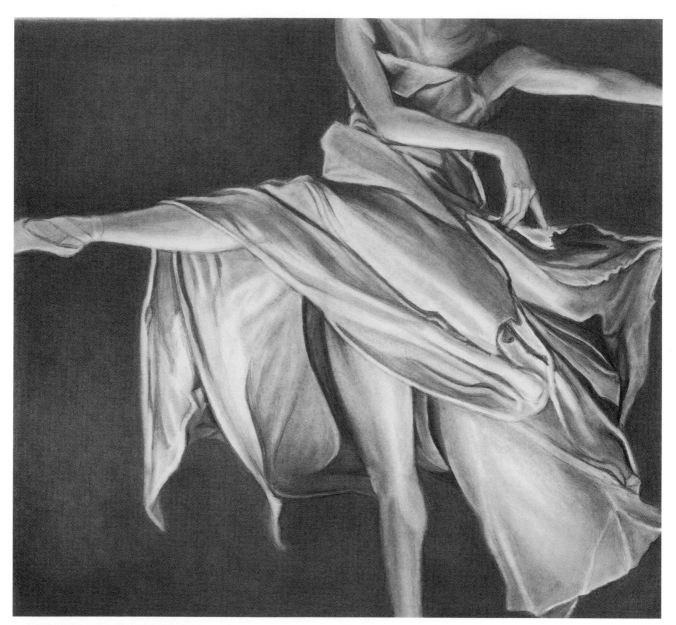

FABRIC MOVES WITH THE PERSON
The body and the clothing that the person is wearing should always be seen as one. The clothing moves with the body and is constantly changing accordingly. The more the person moves, the more the fabric adapts. You can see how this flowing fabric is moving right along with the dancer. Her suspended leg elevates the fabric so it floats through the air.

Lighting

.

Look at the illustrations below. In both drawings, the subtle shapes of the body are created using the five elements of shading. The smooth, gradual tones created with the tortillion give subtle realism to the shape of the female anatomy. The lighting is important for creating this look. Notice where the light is coming from in these images, and where it is causing shadows and highlights to appear.

You can see how the tones affect the mood of the art. Lighting plays a very important role.

LIGHT BACKGROUND
A light background makes a drawing less dramatic, even if there are a lot of shadows.

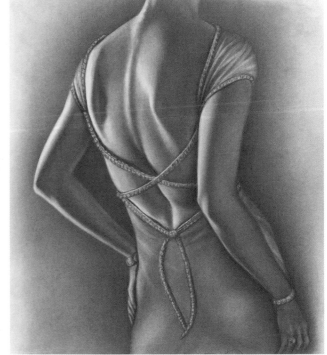

DARK BACKGROUND
A dark background helps illuminate your drawing, making the lighting appear more mysterious.

Sign up for our inspiring and free newsletter at ArtistsNetwork.com.

93

Shadows

.

Even though this drawing is rendered in only black and white, you can obviously see that this is a white shirt, worn with a dark-colored blazer.

Light affects everything. It's what creates the highlights and the shadows. The light bouncing off of a piece of clothing reveals the shapes and contours of both the body and the outfit that it's wearing. The color of the fabric creates even more contrast.

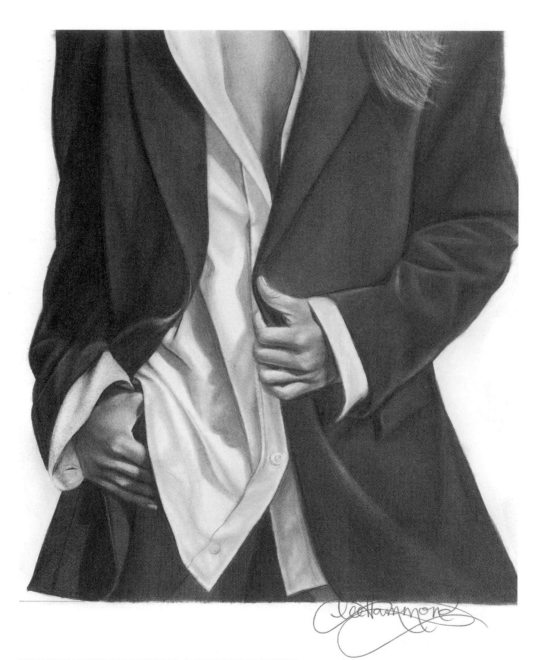

FIND THE LIGHT SOURCE FOR ACCURATE DRAWING
Notice the cast shadows. The bright lighting is coming from the right front. Because of that, you can see the cast shadow of the hand going off to the left. Contrast is the key to realism. This drawing has both lighting extremes and intense color contrast.

Visit ArtistsNetwork.com/draw-realistic-clothing-and-people for bonus materials.

Shadow Close-Ups

· · · · · · · · · · · ·

You will see the five elements of shading in the creases and folds of the shirt. Even though the blazer is dark and smooth, you can still see the subtle movement of the fabric. The subtle light has been lifted where the jacket is raised and curved. You must accurately depict the light source, the body's shape underneath and the movement of the fabric.

Note where the light hits the fabric and casts shadows.

The cast shadows are on the left and are being created by the light coming from the upper right. See how the shape of the cast shadow is actually mimicking the shape of the hand?

Even in an extremely dark area, the effects of light must be seen. Never just fill something in dark—look "into" the shadows!

Sign up for our inspiring and free newsletter at ArtistsNetwork.com.

95

Denim

• • • • • • • • • • •

There are certain fabrics that have a very distinct look to them. Denim is one of those fabrics. You know without question what you are looking at.

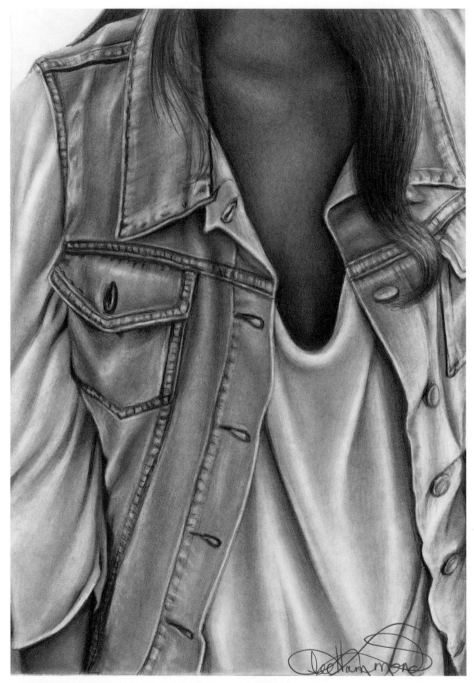

DENIM SEAMS CREATE LIGHT AND DARK PATTERNS
Even in black and white, you can tell this is a denim vest just by the patterns of light and dark created in the seams. These patterns are always seen in denim—they are the fabric's signature look.

Creating Denim Fabric

· · · · · · · · · · · ·

Creating the look of denim is not as difficult as you might think. It's all about the edges and the seams, and how the light is affecting them. Follow along to create the distinct look of denim.

1 APPLY THE GRID METHOD
Use the grid method to capture the shapes of the denim jacket.

2 ADD THE CAST SHADOWS
Apply the cast shadows under the collars and the dark tones in the recessed areas.

3 BLEND
Blend out the drawing with a tortillion to give it a gray tone.

4 CREATE THE HIGHLIGHTS
Use a kneaded eraser to lift the highlights in the folds of the fabric. Use a small stick eraser to lift the more pronounced highlights out of the seams.

Metallic Shine

Shiny material has extremely bright lights created by very dark darks. The shininess of the fabric makes any highlights very extreme.

This is also a wonderful example of a spiral, or coil fold situation with areas of interlocking folds. The fabric is highly creased as it wraps around the cylindrical form of the body.

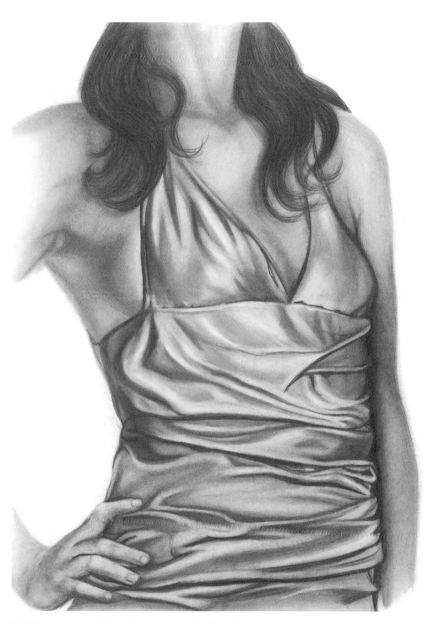

SHINY FABRIC CREATES INTENSE DARKS AND BRIGHT HIGHLIGHTS

This shirt could be made out of a metallic fabric, like lamé, or it could be silk or satin. Either way, it reflects the light brightly off of its surface.

The shiny nature of this fabric makes the highlights of the coil fold very bright. The movement of the fabric encompassing the roundness of the body is exaggerated due to the lighting.

Sign up for our inspiring and free newsletter at ArtistsNetwork.com.

99

Sheer Fabric

In sheer fabric, the light goes through it rather than bouncing off it. This means that lights and darks are more subtle. This allows you to see the form of the body through the fabric, giving the fabric a light and airy appearance.

The folds are subtler and they loosely drape. Even if the light were extremely bright, the surface of the fabric would not reflect it as much, due to its transparent nature.

You can see how delicate the fabric is just by the subtle lights and darks that are used to create it.

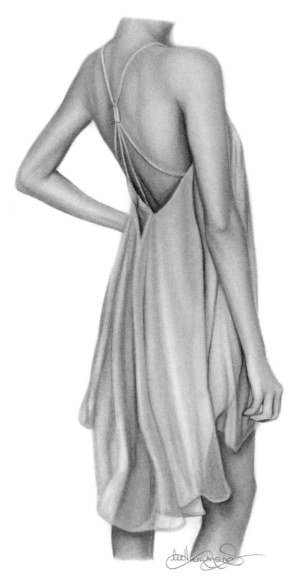

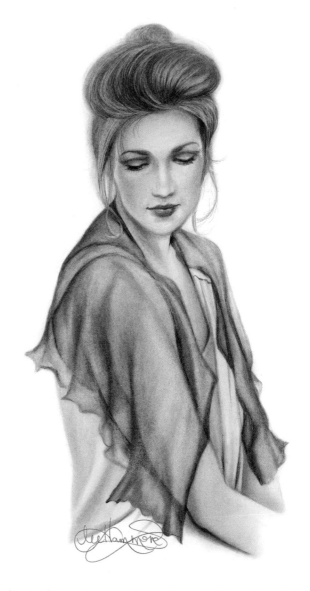

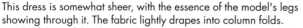

This dress is somewhat sheer, with the essence of the model's legs showing through it. The fabric lightly drapes into column folds.

The fabric of this dress is sheer, but not overly transparent. You can see the sheer quality in the areas of overlap, and how the legs are still seen underneath.

This shawl is very transparent, revealing everything underneath it. The subtle lighting gives this a delicate look.

The fabric of this shawl is more transparent than the dress example. The arms and shirt underneath show right through it. If the model were wearing a printed fabric underneath, that would show through as well.

Transparent Fabric With Patterning

• • • • • • • • • • • •

This lace sleeve shows how a sheer fabric can also contain patterning. While it may look extremely difficult to create, it's actually easier to draw than you may think.

This is all about the lifting of light. This is where small stick erasers really come in handy, because you can actually "draw" the light patterns back into the dark shaded areas.

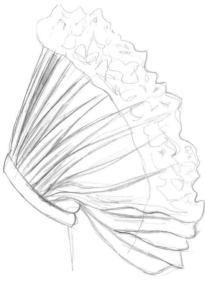

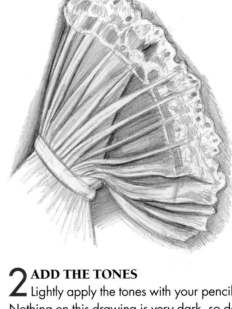

1 DRAW THE OUTLINE
Create a light drawing of the shapes of the sleeve. Use the grid method, if necessary, to achieve an accurate line drawing. The lace pattern is just an illusion, so do not stress over the actual shapes.

2 ADD THE TONES
Lightly apply the tones with your pencil as shown. Nothing on this drawing is very dark, so do not over-draw it. You can see how the gray tones are creating the light patterns. Always remember that dark creates light, and notice the use of tone in the background to create the light edges.

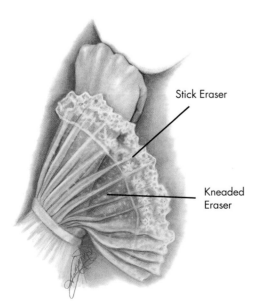

Stick Eraser

Kneaded Eraser

3 BLEND
Use a tortillion to blend out the tones. You can add the look of a hand if you'd like.

All of the delicate lace patterns are lifted back out with the stick eraser once the tones are smooth. The fine point of this eraser creates a very deliberate line of white. It's great for creating distinct edges.

For the more delicate areas, that aren't as white and distinct, use a kneaded eraser formed into a point with a very light touch.

Sign up for our inspiring and free newsletter at ArtistsNetwork.com.

101

Delicate Fabrics

· · · · · · · · · · · ·

Even when dealing with fabrics not quite sheer or transparent, you can describe a delicate fabric using darks to create lights. The process for creating it is just the same. The illusion of the delicate beadwork was created with both the pencil and the eraser. Using a darker background made the dress appear even lighter and more delicate. By contrasting against the background, the light color of the fabric becomes the focal point.

Everything you draw is an illusion that you create with your drawing materials. By now, you can probably see the repetitive process that is used in drawing. Everything reduces down to the same elements. What separates things is the amount of time it takes to create the illusion.

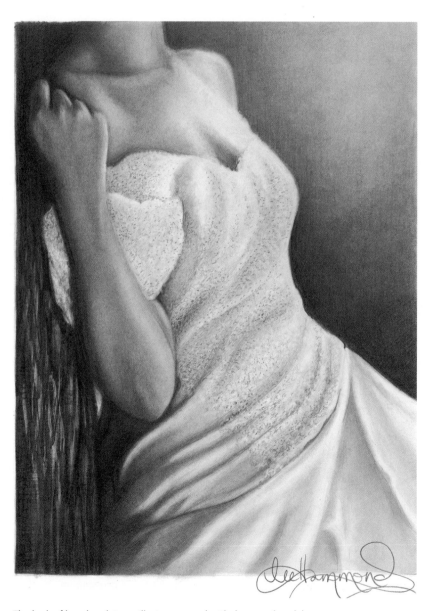

The look of beadwork is an illusion created with the pencil and the eraser. The darkness of the background helps make it stand out.
Look at how the left side of the dress seems to disappear into the background.

Visit ArtistsNetwork.com/draw-realistic-clothing-and-people for bonus materials.

HOW TO CREATE THE ILLUSION OF BEADWORK

The folds were first established with the use of the five elements of shading. Then, the look of beads was added by slowly dotting with the pencil, sometimes called *stippling*. Both the kneaded eraser and the small stick eraser were then used to add the light effect into the drawing. I used the stippling method with the erasers as well.

This technique requires a back-and-forth approach of adding dark and lifting light. It can be very time-consuming. Do not quit too soon. Often the difference between my work and your's is simply the amount of time devoted to the piece.

BACKGROUNDS CAN HELP

Even though this is not a part of the dress or the figure, you'll often need to draw the surroundings. This look of tree bark was done using the same process of drawing. The darkness was drawn in with the pencil and blended, and the highlights were lifted using a kneaded eraser. Can you see the common approach to drawing all things?

The fading of the figure into the background adds to the realism of the drawing.

These column folds were created using the five elements of shading.

Sign up for our inspiring and free newsletter at ArtistsNetwork.com.

103

Peasant Shirt

• • • • • • • • • • • •

This shirt is a combination of everything we've covered so far. Look at the close-ups and you can see how the same techniques were used. It's a repetitive process of the following steps:

1. Create an accurate line drawing using the basic shapes.
2. Add tones with the pencil.
3. Blend the tones with the tortillion.
4. Lift the light with your erasers.

Remember that there may be multiple modifications within each step. Do not rush the process!

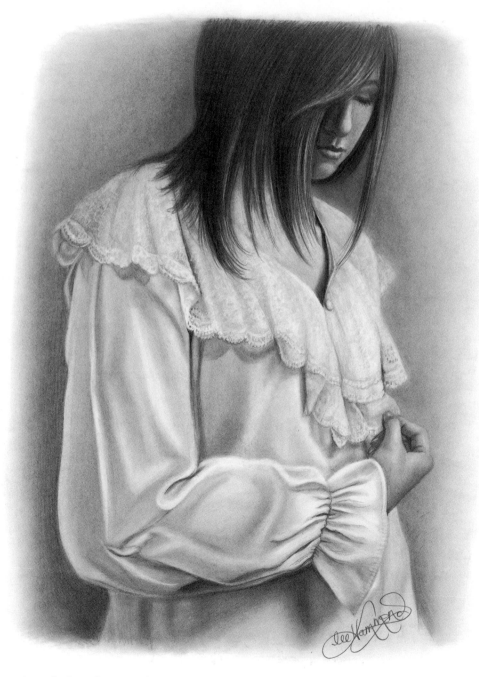

The methods used to create this shirt closely resemble the techniques from the previous examples.

LIGHTING

You can see how the light is coming from the front right, and the shadows are on the back. Lifting light with the erasers, and adding dark with little dots of the pencil, create the delicate look of lace.

SOFT EDGES

This area is a group of column folds. They were created first using the five elements of shading on the basic shapes. The texture of the lace was then added on top.

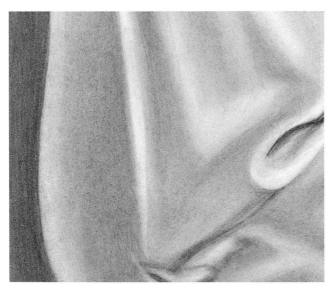

CREASES

The lighting is what creates these folds. The crisper the edge of light against a dark surface, the more severe the fold appears. This is a *hard edge.* It is much more defined than the soft edges of the other column folds.

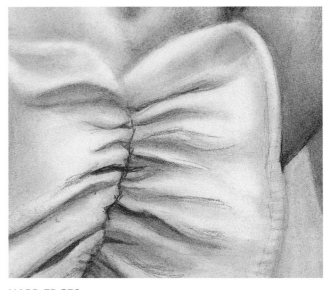

HARD EDGES

The elastic in this cuff makes the fabric pucker where it's gathered. Look carefully at how the hard lines were used to create it.

Sign up for our inspiring and free newsletter at ArtistsNetwork.com.

105

Ribbed Sweater

.

The valleys in the ribbed sweater catch the shadows while the hills of the ribbing are lighter. Notice how the darks create the lights. Look at how the subtle pattern seems to go in and out of the darkness. It seems to disappear all together in some of the highlighted areas.

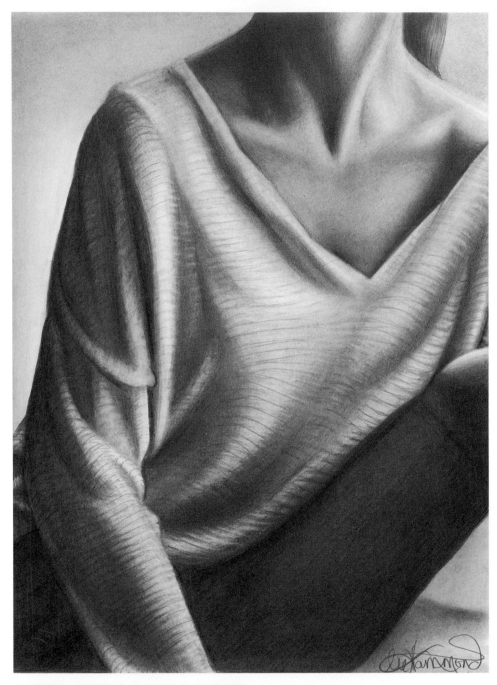

LIGHTING AFFECTS THE LOOK OF TEXTURE
The light texture of the sweater is highly affected by the lighting in this drawing. The use of a blended background places all of the focus on the front of the sweater. Look at how I used the Dark Over Light and Light Over Dark theories to create it.

Visit ArtistsNetwork.com/draw-realistic-clothing-and-people for bonus materials.

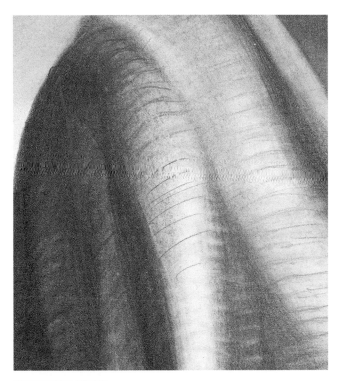

FADE INTO LIGHT

Look at how the texture lines of this sweater seem to completely disappear into the light. The bright highlight makes them seem to vanish. If the lines were drawn so they were more visible, the illusion would be lost. Notice how the lines follow the curve of the fabric.

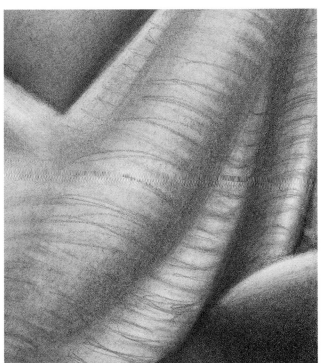

OBVIOUS TEXTURE

The curves of the lines follow the contours of these column folds. Notice how the lines are more visible here, since the light is not as bright.

FADE INTO DARKNESS

These texture lines seem to evaporate into the darkness. The use of light and dark is the most important part of a drawing, so study your references well.

Sign up for our inspiring and free newsletter at ArtistsNetwork.com.

107

Crochet

• • • • • • • • • • •

Drawing highly textured things is not as hard as you think. While this crocheted top looks quite daunting, I find this type of thing easier to draw than something that is overly smooth.

Follow along on the next page to create a texture like this. I zoomed in on just a portion of the shirt.

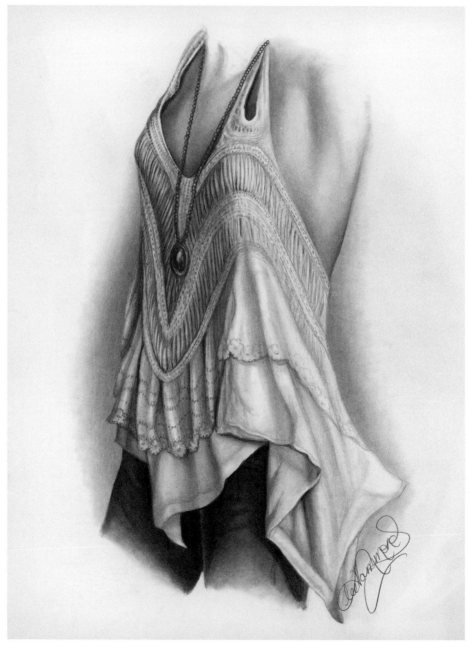

Sometimes what looks extremely difficult can actually be easier to draw than something that is overly smooth and blended. That's because the patterns are so distinct, and they are made up of illusion.

Something that is very smooth is harder because getting the blend to be smooth with no irregularities is not easy, particularly in a large area.

Visit ArtistsNetwork.com/draw-realistic-clothing-and-people for bonus materials.

Creating the Crochet Look

· · · · · · · · · · · ·

Follow along to create the illusion of crochet.

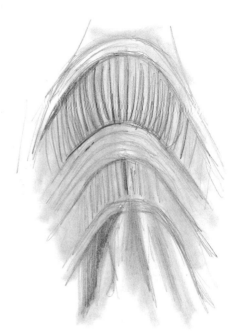

1 DRAW THE OUTLINE
Begin with a light drawing of the basic shapes and curves.

2 ADD THE DARKS AND BEGIN BLENDING
Deepen the dark areas between the stitches. This will separate them. It's not important to be exact, for this is an illusion.

Blend the tones out with your tortillion to smooth it out. Develop the look of the column folds.

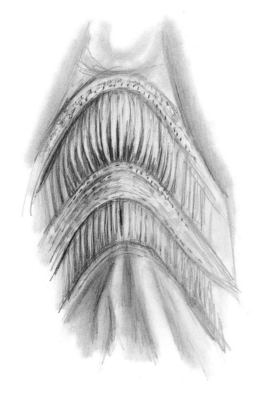

Highlighting With an Eraser Stippling

3 REFINE AND FINISH
Use the dotting or stippling approach to create the textured look of the bands. Use a kneaded eraser to lift the look of highlighting.

Sign up for our inspiring and free newsletter at ArtistsNetwork.com.

109

Cable Knit

• • • • • • • • • • •

This is another example of something that is richly textured. While at first glance it looks extremely difficult, the truth is, it's more time-consuming than anything else.

The patterns of this sweater were created by closely examining the shape of each of the cables. You can see how each one is altered due to the coil folds around the arm. It's important to create the folds first, and then add the details on top.

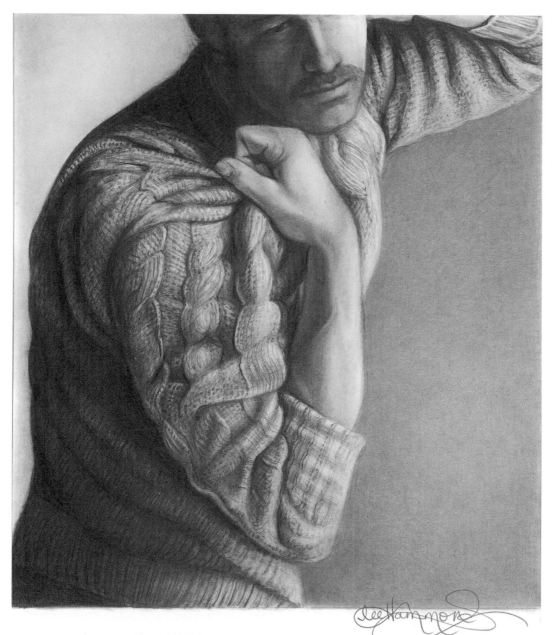

CREATE THE FOLDS FIRST FOR HEAVILY TEXTURED CLOTHING
Creating the rich texture of this knitted, cabled sweater is time-consuming but not difficult. Each area of the sweater was drawn using different techniques.

Visit ArtistsNetwork.com/draw-realistic-clothing-and-people for bonus materials.

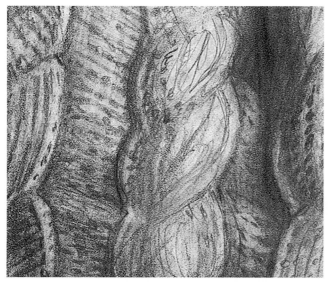

CABLES

The form of this sweater and the shapes of the cables are created using the five elements of shading. Look and you will see deep cast shadows and an edge of reflected light running down the sides of each cable.

The shape of each cable is important to capture before adding details. The creases and folds affect these shapes. Once the form is created, add small pencil lines and dots. Remove the highlights with a kneaded eraser.

RIBBING

Again, first create the coil fold, then add the texture detail using pencil lines and dots. Lift highlights with a kneaded eraser.

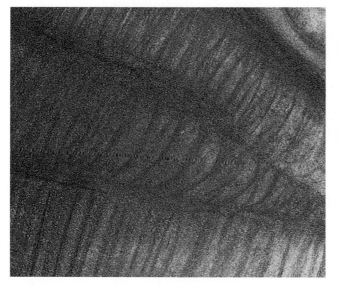

LINES

Look at all of the line work used to create the waistband of the sweater. Here you place the shading first, allowing the sweater to gradually fade into the darkness. Add texture and details on top.

STIPPLING

This area of the sleeve was done with stippling. Once the coil fold was created with the shading, the dotting technique was placed on top, giving the sleeve its textured look. Using a dark background helped make the light areas stand out.

Sign up for our inspiring and free newsletter at ArtistsNetwork.com.

111

Beads and Lace

• • • • • • • • • • • • •

This shirt combines two elements: transparent, sheer fabric
and textured beading and lace details.

I think you will be surprised at how much easier it is
than it looks!

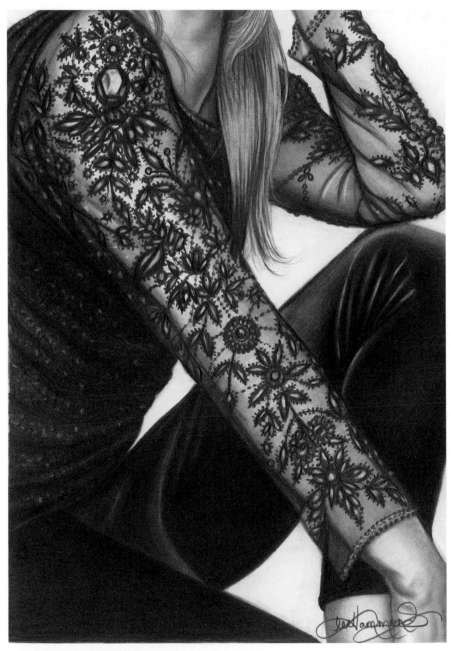

DETAILING IS LARGELY ILLUSION
Creating the look of big beads and small details seems harder than it
really is. Just be willing to devote the proper amount of time to a drawing
like this. Much of this is not exact—it's an illusion.

Visit ArtistsNetwork.com/draw-realistic-clothing-and-people for bonus materials.

Beaded and Lace Sleeve

· · · · · · · · · · · ·

Follow along to create this fun textured shirt. It combines the sheer quality of the fabric with the small details of the beading.

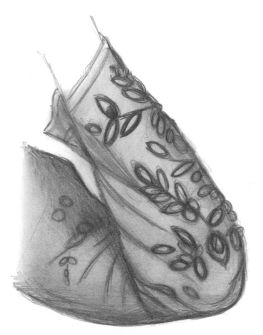

1 DRAW THE OUTLINE
Create a line drawing of the shapes. Start with the shape of the arm first. Create the creases and folds second. Add the shape of the embellishments third.

2 ADD THE TONES
Add gray tones to the drawing with your pencil, and blend them all out with your stump or tortillion. This creates the transparent look of the fabric.

The front part of the arm is lighter. There are cast shadows where the arm is creased, and in the creases of the fabric.

Once everything is blended, deepen the darkness of the embellishments with the pencil. Do not blend them!

3 ADD THE BEADING
Use stippling to add the look of small beads and lace. You can see them all around each motif and the edge of the cuff. Use your erasers to lift out the light areas, making the motifs look like large beads.

Lift out the highlights on the edges of the folds.

Sign up for our inspiring and free newsletter at ArtistsNetwork.com.

113

Plaid

· · · · · · · · · · · ·

Like some of the detailed fabric we have already covered, creating plaid fabric can also be time-consuming. The patterns of the plaid must follow the movement of the fabric. Creases and folds, and the shape of the body underneath, distort the patterns, making them difficult to follow.

Draw the shapes and form first with the five elements of shading. Add the pattern on top, using pencil for dark and erasers for light. This precise pattern was created using a small stick eraser. It allows you to erase a very distinct line. It is actually like drawing in reverse, where instead of drawing a dark line, you are drawing a light one.

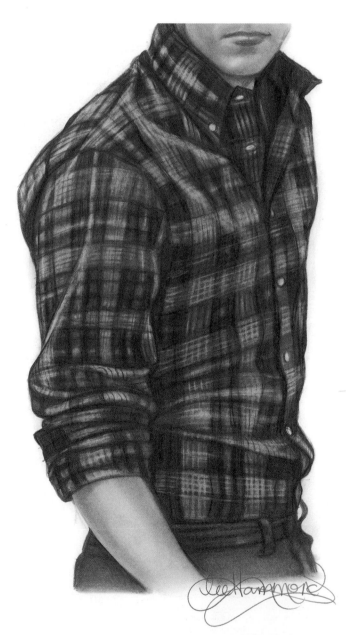

PATTERNS CHANGE WITH WRINKLES AND CREASES
The plaid pattern is highly altered by the fabric and creases of the shirt. The patterns must stay true to the form and must seem to be moving with the fabric. This takes close observation.

Visit ArtistsNetwork.com/draw-realistic-clothing-and-people for bonus materials.

CREATE LINES

The plaid pattern was created using a stick eraser. Draw in white lines with the eraser and dark lines with the pencil. Remember that the patterns must follow the movement of the fabric. While it doesn't have to be exact, it must be believable.

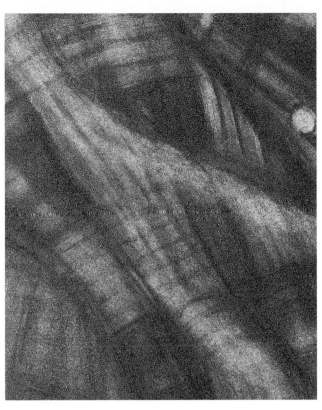

HIGHLIGHTS

The look of highlighting here interrupts the look of the plaid pattern. Lift the light with a kneaded eraser. It allows for a much more delicate removal of light, making it appear as a light area of highlight, rather than a hard line.

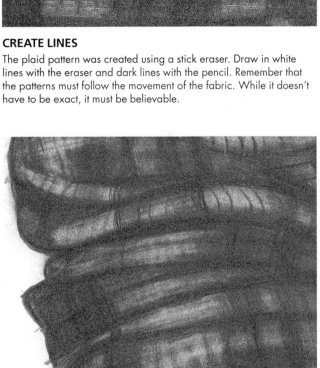

COIL FOLD

The coil fold, wrapping around the arm, completely obliterates the plaid pattern. However, some of it still shows and must be there. This is where you must study your reference and replicate what it is you are looking at. Do not allow your thoughts to interfere. Draw what you see, not what you think you know.

LEE'S LESSONS

Kneaded Eraser: Use for soft edges.
Stick Eraser: Use for hard edges.

Sign up for our inspiring and free newsletter at ArtistsNetwork.com.

115

Plaid Scarf

• • • • • • • • • • •

I cannot tell you how many times my students will want to simplify their drawings by making a plaid shirt into a plain one. How boring! Drawing plaid is part of creating the character in your subject. It helps to create a story. Look at the drawing in the back of the book titled *Zander*. Part of the cuteness of that drawing is my great-grandson's little, plaid shirt. The drawing would not have as much character without it!

Don't be tempted to avoid things in your drawing that appear difficult. You will see, with practice, that everything you draw is done using the same procedure. You can do it!

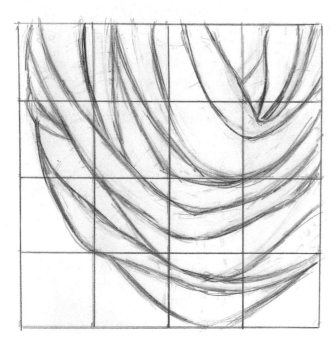

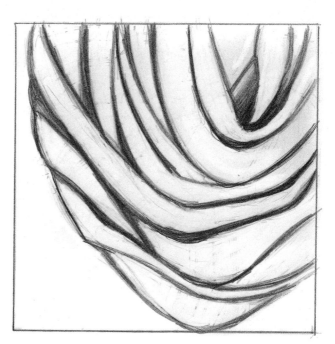

1 DRAW THE OUTLINE
Create a 4" × 4" (10cm × 10cm) grid. Draw it lightly. The squares will help you see the shapes of these drape folds more clearly. There are a lot of lines here to capture. Take your time, and draw what you see in each box, one at a time.

2 BEGIN DEVELOPING THE FOLDS
When you are sure of your accuracy, carefully remove the grid lines with your kneaded eraser. With your pencil, deepen the dark areas where the fabric is recessed into the folds.

Visit ArtistsNetwork.com/draw-realistic-clothing-and-people for bonus materials.

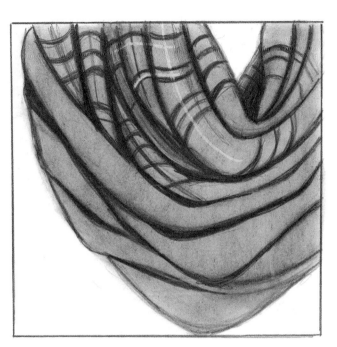

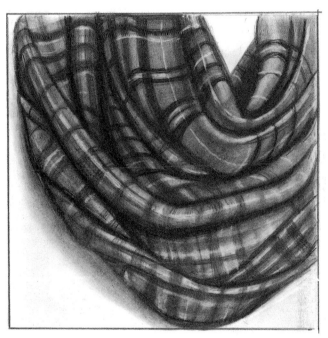

3 ADD THE TONES
Establish the tones first. The pattern of the plaid goes in last. Apply a gray tone to the entire drawing, and blend it out. This represents the basic color of the fabric. Once it is even and smooth, start to apply the lines of the plaid with your pencil. Study how they curve with the fabric, and go in and out of the folds.

4 REFINE AND FINISH
Continue adding the dark lines of the plaid to establish the pattern. Go slow, and follow the way they conform to the movement of the material.

When the pattern has been established, remember it doesn't have to be perfect, create the light lines of the pattern with the stick eraser.

Finish the drawing by deepening the shadows with your pencil. Blending again will soften the look of the pattern, making it more realistic.

Lightly lift some highlights off of the raised areas using a kneaded eraser.

Sign up for our inspiring and free newsletter at ArtistsNetwork.com.

117

Smocked Plaid

• • • • • • • • • • • •

Many of the things previously covered have collided into one drawing. *Smocking* is where embroidery gathers fabric, making it stretchable. This creates lots of column folds. In a smocked plaid, you'll see column folds forming their tube-like formations. You'll also notice texture being created with the smocking, where fabric is being pulled together.

Carefully observing your subject matter, and placing the shapes and tones accordingly, creates all of this.

Each section of this drawing has valuable details to learn from. All of these must be fully understood to render them properly. Try drawing close-up sections in your segment drawing notebook for practice.

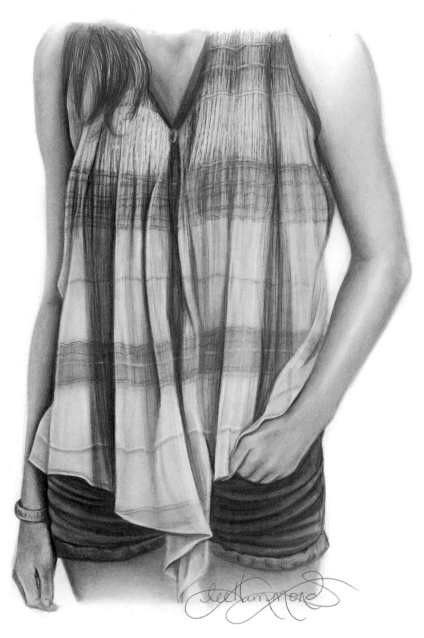

A plaid, smocked shirt is the perfect combination of folds, patterns, values and textures.

Visit ArtistsNetwork.com/draw-realistic-clothing-and-people for bonus materials.

SMOCKING

Remember that texture is always added last. First the shape of the body and shirt is created. Then, the shapes of the folds are developed. The patterns of light and dark are next.

To make the smocking, use quick pencil strokes. These lines don't have to be perfect. Quick lifts of light are added with a kneaded eraser. This is a back-and-forth process, and it takes time to develop it. Do not give up on it too quickly!

COLUMN FOLDS

Notice how the patterns of the fabric go in and out of these column folds? The shapes of the folds are created first, with the five elements of shading. Then add stripes with both a pencil and an eraser. Use a tortillion to blend out the stripes a bit, so they look lighter and less hard edged.

Use a small stick eraser to pull the reflected light out along the edges of the shirt's hem.

REMEMBER DENIM

The light-and-dark patterns here tell us that these are denim shorts. Not only does the seam along the bottom have a recognizable pattern, but the fabric looks as if it has faded in the creases.

Sign up for our inspiring and free newsletter at ArtistsNetwork.com.

119

Drawing Metal

• • • • • • • • • • • •

Often, you will see metallic aspects to clothing, such as buckles, zippers and rivets. Drawing metal is easier than you think. These buckles, as seen on a pair of overalls, are really just extreme patterns of light and dark.

LEE'S LESSONS

Drawing circles in any type of drawing can be a challenge. While our brain and eyes see "round," rarely is a circle perfectly round. Only when a circle is seen straight on is it perfectly round. Any other time it is actually what is called an *ellipse*. An ellipse is simply a circle in perspective.

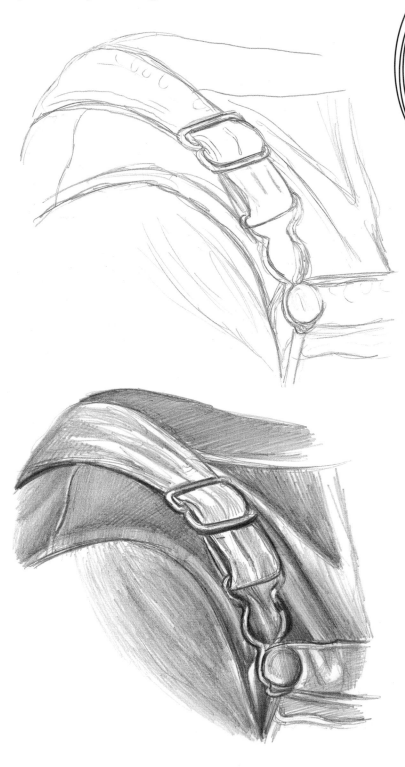

1 CREATE THE LINE DRAWING
Use this as a guide to draw an accurate line drawing. This is where all of the shapes are figured out. Notice how the button is not a perfect circle, but an ellipse.

2 DRAW THE PATTERNS
Draw in the patterns of light and dark with your pencil. Look at how the metal of the hardware is broken up into extreme patterns of light and dark.

120

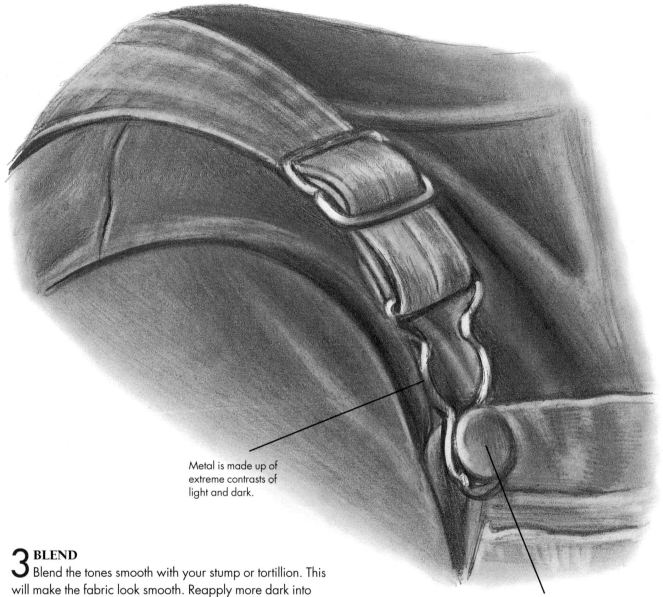

Metal is made up of extreme contrasts of light and dark.

Look at this button. It is a slight ellipse. The highlight along the left edge shows the thickness of it.

3 BLEND

Blend the tones smooth with your stump or tortillion. This will make the fabric look smooth. Reapply more dark into the deep areas of the folds if necessary. Look at how the darkness of the shirt now makes the metal buckles stand out.

With a kneaded eraser, carefully lift out the highlights from the folds. Use it to lift the characteristics of the denim. You can see the telltale patterns of denim everywhere.

With a small stick eraser, draw the bright white areas out of the metal buckle. With your pencil, darken the dark patterns of the metal. This is what makes it look shiny.

Sign up for our inspiring and free newsletter at ArtistsNetwork.com.

121

Stripes

· · · · · · · · · · · · ·

The shirt has light stripes on dark fabric. The tie, on the other hand, has dark stripes on light fabric. Look at the close-ups and see how the two have been drawn differently.

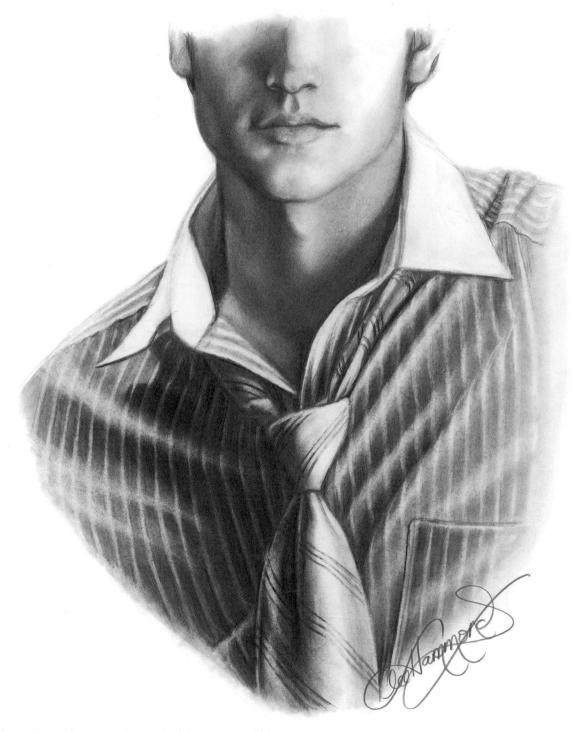

This shirt-and-tie combo is a good example of drawing striped fabric.

Visit ArtistsNetwork.com/draw-realistic-clothing-and-people for bonus materials.

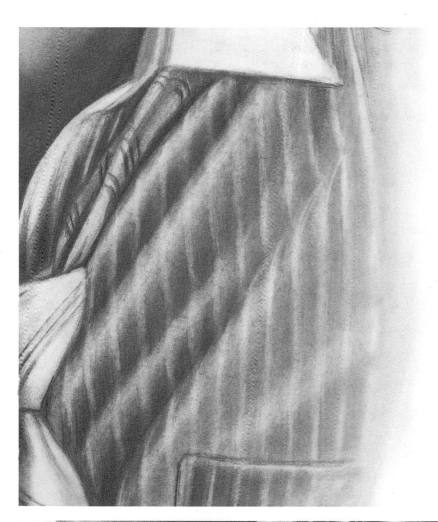

LIGHT SHAPES, DARK FABRIC

The shirt is a darker fabric with white stripes. The ripples and movement of the interlocking folds were developed first with the five elements of shading. The tones were well blended for smoothness. The actual stripes were lightly drawn out with a small stick eraser. Notice how the stripes follow the ins and outs of the creases.

The highlights were lifted down the protruding area of each fold with a kneaded eraser. This makes the light look like it's reflecting off of the surface, and not a part of the pattern.

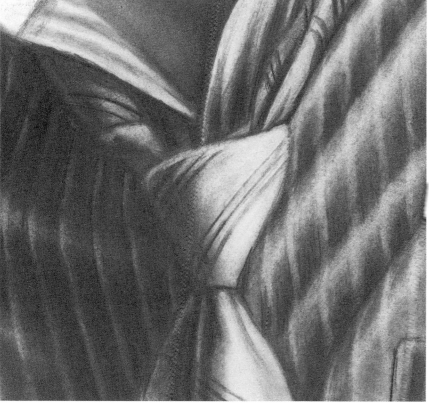

DARK STRIPES, LIGHT FABRIC

The shape of the tie was created first. It makes column folds where it comes out of the knot. The blending technique was used to create the cylinder or cone-like shapes.

The stripes were added last, with light, delicate pencil strokes. Notice how the stripes of the tie, and the stripes in the knot of the tie, go in different directions? This is due to it being tied in a knot, changing the direction of the fabric.

Since the tie is made of silk, it is very reflective. Lots of light was lifted down the front with a kneaded eraser.

Sign up for our inspiring and free newsletter at ArtistsNetwork.com.

123

Altered Stripes

• • • • • • • • • • •

The striped T-shirt is being pulled and stretched, and tied into a side knot. This pulling creates repeated interlocking folds, and these folds interrupt all of the stripes.

Look closely and you can see how the stripes go in and out of the folds.

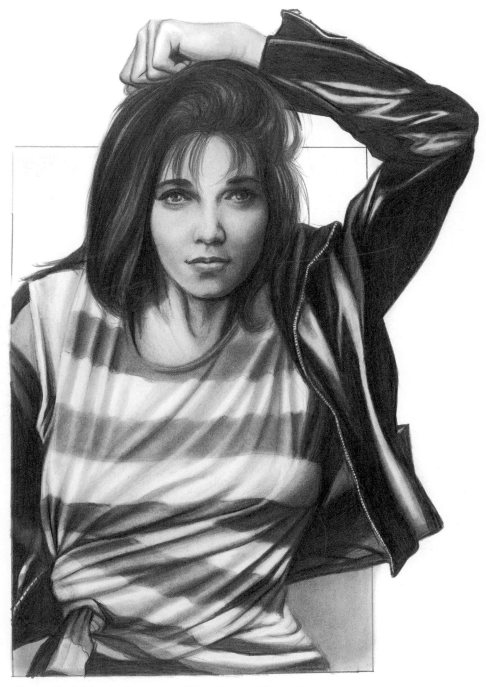

These wide, bold stripes look very realistic with the addition of the creases and folds. The five elements of shading applied to each fold creates dimension and realism.

Visit ArtistsNetwork.com/draw-realistic-clothing-and-people for bonus materials.

Stripes

· · · · · · · · · · · · · ·

Drawing stripes like this uses the same principles you've used before. It all boils down to shape, tones, shadows and highlights. Never forget the five elements of shading or the five folds. Follow along and draw these bold stripes!

1 DRAW THE OUTLINE
Use the grid method to help capture the shapes of the shirt and stripes. Be as accurate as possible. There are a lot of lines here, so go slow!

2 FILL IN THE DARKS
Fill in the dark stripes and blend them out until smooth. Place the dark areas in the creases of the fabric. This creates cast shadows.

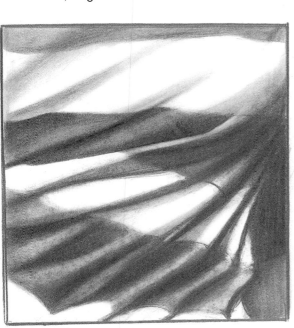

3 BLEND
Blend into the light stripes to create the look of folds and creases. These interlocking folds all have the five elements of shading within them. Lift reflected light out with a kneaded eraser.

Sign up for our inspiring and free newsletter at ArtistsNetwork.com.

125

Polka Dots

.

None of these dots are perfect circles, because the shapes within the fabric are altering them. Some appear very distorted as they go into a fold. Some do not even look like circles at all. Once again, good observation is key to capturing them.

I have seen some good drawings fall short because the shapes of the circles were not accurate. Our mind wants to correct the circles, making them more rounded. When this happens, it changes the perspective, making the surface look flat, like we are viewing it straight on.

Notice how the shading is carried through each dot. Because they are a part of the fabric, the shape and form comes first.

Always remember: ellipses, not perfect circles!

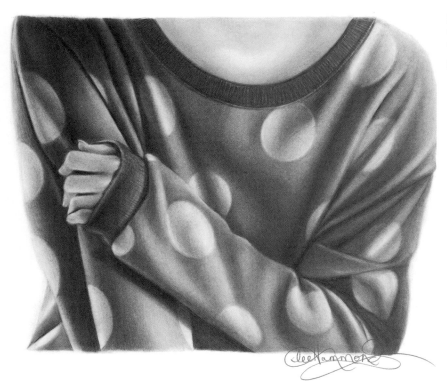

POLKA DOTS ON FABRIC ARE ELLIPSES
This sweater is an example of polka dots. They are not perfect circles—they are ellipses, going in and out of the fabric.

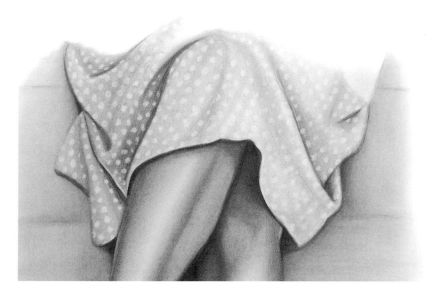

SMALL POLKA DOTS ARE ELLIPSES, TOO
The small little dots of the dress were carefully drawn in with a small stick eraser. When creating them, it is important to look at the movement of the fabric, making sure the dots go in and out of the folds, and change shape as they do.

How to Draw the Polka Dot Sweater

· · · · · · · · · · · · · · ·

The technique for drawing all of this remains the same. It is the same procedure used for all of the drawings in this book. Drawing is very repetitive.
1. The shapes always come first, so figure out the folds first.

2. Draw the dots on top of the folds. Pay attention to the perspective while drawing in the dots. Some no longer look like dots at all.
3. Put in the color of the sweater and blend, leaving the dots white. Then,

pull the shading through the dots with a tortillion to connect them to the movement of the fabric. When that is done, use a kneaded eraser to pull highlights from all of the raised areas.

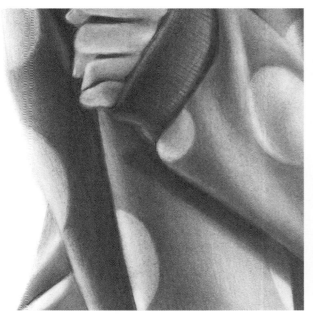

HALF DOTS
These circles on the sleeve are being cut in half because they are wrapping around the arm. This perspective tells us that there is another side to this arm.

CIRCULAR DOTS
This is the only dot of the sweater that still resembles a circle. But, you can still see how the movement of the fabric is altering its shape. Look at how the shading running through it makes the circle appear like it is sinking into the fold.

FOLDED DOTS
The dots on the shoulder have been completely altered due to the interlocking coil folds of the sleeve. Only a portion of them is still visible.

Sign up for our inspiring and free newsletter at ArtistsNetwork.com.

127

Bows

• • • • • • • • • • • • •

Many articles of clothing have bows attached. They are really just extreme folds at work. This dress has a unique bow attachment in the back. It hooks to the edge of the dress and follows the curves of the body.

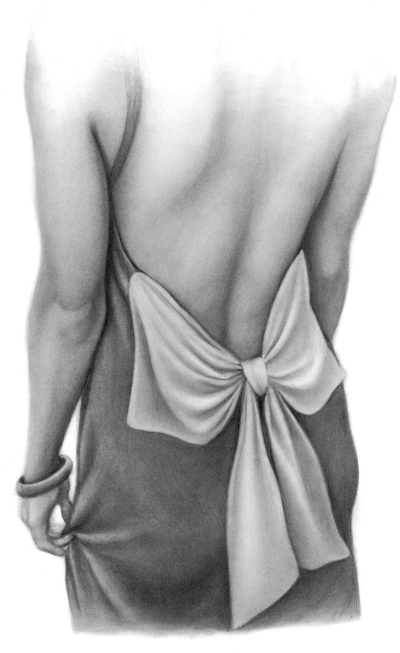

Here is a unique bow enhancement. The knot of a bow forces the fabric into drape folds. The part that hangs free is made up of tubular, column folds.

Visit ArtistsNetwork.com/draw-realistic-clothing-and-people for bonus materials.

Folded Bows

• • • • • • • • • • • •

Use this exercise to learn how to draw a bow. A bow is just a
piece of fabric with an extreme case of the folds!

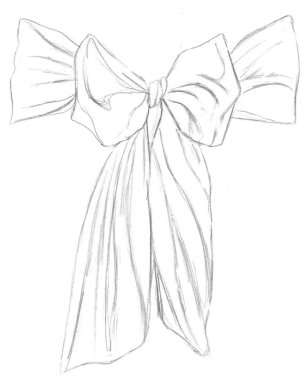

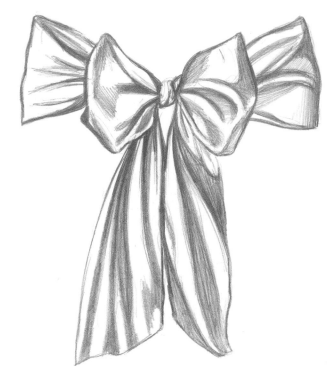

1 CREATE THE LINE DRAWING
Draw an accurate line drawing of the bow. Follow the
creases as they come out from the center knot.

2 FILL IN THE DARKS
Add the darkest areas first. This is where the fabric is
creased and recessed.

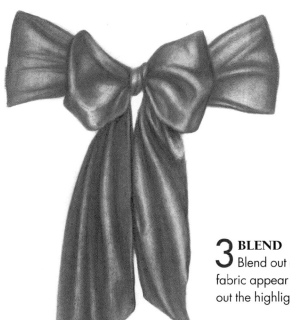

3 BLEND
Blend out all of the tones with a tortillion to make the
fabric appear smooth. With a kneaded eraser, carefully lift
out the highlights.

Buttons

• • • • • • • • • • •

Buttons are another detail of clothing that are important to capture accurately, even though they are small. They're also another example of circles turning into ellipses, and they tend to have a thickness to them.

When drawing costumes or uniforms, buttons can be the most important part of telling the story. Look in some clothing catalogs for references, and enter some into your segment drawing notebook.

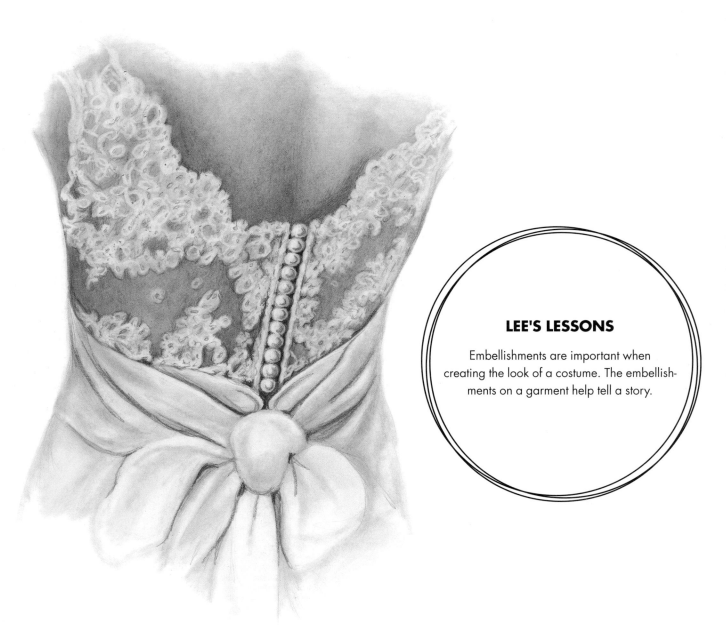

LEE'S LESSONS

Embellishments are important when creating the look of a costume. The embellishments on a garment help tell a story.

EACH OF THESE BUTTONS IS A SPHERE EXERCISE!
This wedding dress was created by relying heavily on a small stick eraser. Each pearl button is a sphere exercise. The small highlights were drawn out with the stick eraser, and so was the lace.

Visit ArtistsNetwork.com/draw-realistic-clothing-and-people for bonus materials.

Drawing Buttons

• • • • • • • • • • •

To look good in a drawing, buttons must look multi-dimensional. This exercise will show you what to look for when drawing buttons.

1 CREATE THE LINE DRAWING
Start with a simple line drawing of the button and collar. Since we are viewing this button straight on, it is very circular rather than elliptical.

2 FILL IN THE DARKS
Add some dark tones behind the button in the button-hole, and underneath it. Place a cast shadow under the collar's edge.

Look at the shadow edge inside of the button. This gives it dimension. Create the thread holes as well.

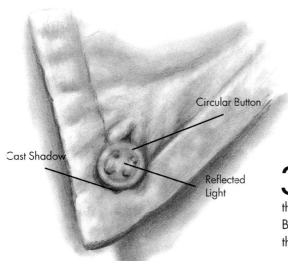

Circular Button

Cast Shadow

Reflected Light

3 BLEND
Blend the tones with a tortillion. Use shading to create the indentations on the fabric along the edge of the collar. Be sure to leave reflected light along the edges. This gives the collar dimension.

Sign up for our inspiring and free newsletter at ArtistsNetwork.com.

131

Zippers

Drawing zippers can be a problem when drawing clothing. The small details are often overdrawn, making them appear cartoon-like. The enlarged drawing shows what a zipper looks like up close. It is important to know what it is you are drawing.

ZIPPER DETAIL
A zipper is an important part of clothing that must look believable. It is easy to overdraw the details.

SMALL PENCIL LINES CAN CREATE THE ILLUSION
This shows how even a very small representation of a zipper is still important—it must appear recognizable. This one was done with very tiny pencil strokes.

MOST OF THE TIME, ZIPPERS AREN'T PROMINENT
You can see in this example how the details of the zipper are not as noticeable due to the size. Even though it is hard to see, what you do see must appear believable.

Women's Shoes

Often the shoes are a part of the outfit or costume that the drawing is depicting. You must study how the feet and the shoes work together.

Eventually, you will want to draw a portrait scene where the shoes are included. Without having some practice and understanding, this could be the area that undoes the professionalism of your work.

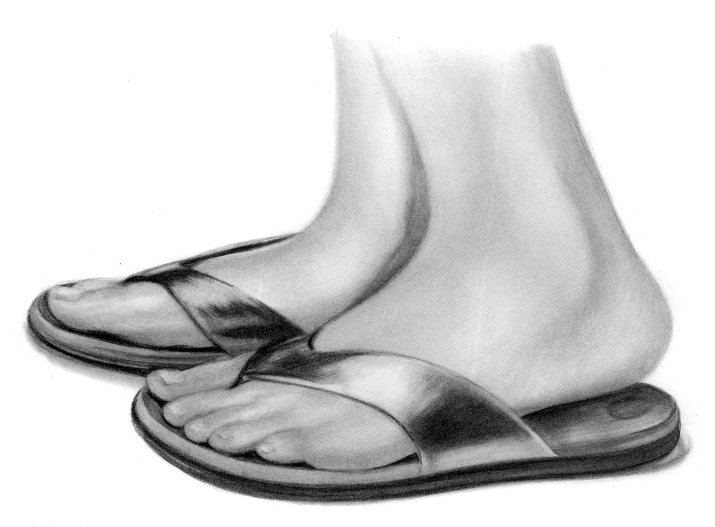

SANDALS

Let's start with an example of sandals. Here you can see both the feet and the footwear. While this may not be very exciting to draw, and is not something you would want to frame, it is still important to practice.

Sign up for our inspiring and free newsletter at ArtistsNetwork.com.

133

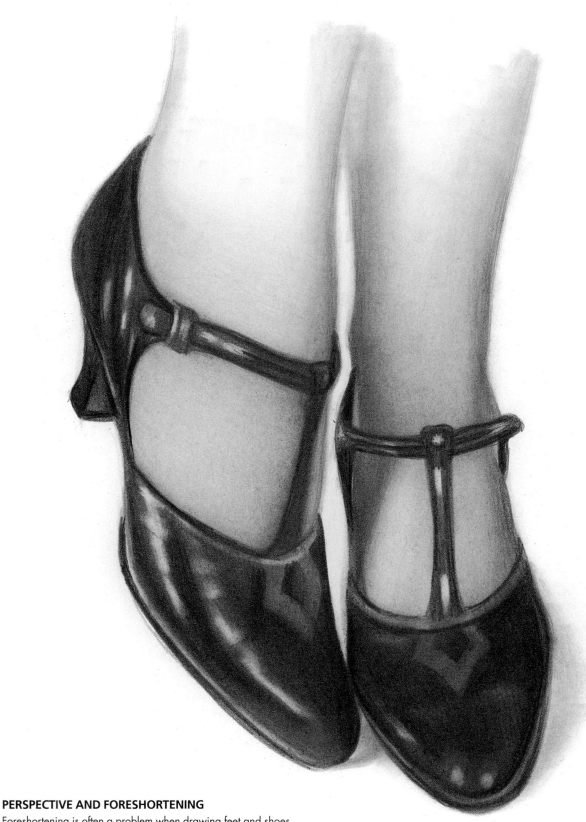

PERSPECTIVE AND FORESHORTENING

Foreshortening is often a problem when drawing feet and shoes. Rarely will you see the feet completely from the side. Usually, you will see them going in different directions. You can see here how the perspective changes dramatically, altering the way you see the shoe and foot. The foot on the right shows mostly the top of the foot, with the length of it lost visually. You see much more of the side in the other one.

Men's Shoes

Like hands, the male feet are generally broader and boxier. These examples of men's shoes show the differences.

You can clearly see the effects of perspective when looking at these shoes. The theory of foreshortening is hard at work here.

Artistically you can see how the blending technique created the look of shiny leather. The highlights are very important to giving the shoes the look of recently being polished!

This view shows more of the length of the shoes, and the highlights make them appear very shiny.

Foreshortening makes this shoe appear very short and wide.

THINGS TO REMEMBER

- For references, look to the Old Masters or take a camera and go looking for references to capture in a photo.
- Statues are wonderful to draw from. They are stationary, so you can actually go outside and draw from them in life—there's no risk of your subject moving! Because they are typically outdoors, the sunshine illuminates them with strong contrasts, making their shapes more obvious.
- Clothing and its embellishments give an artist the chance to capture many different nuances. I highly encourage you to not be afraid of clothing, and go for the small details. It is challenging, yes, but it takes on a sense of realism and brings your art to life.
- If you still need practice, get out your segment drawing notebook and study different aspects of clothing.

Sign up for our inspiring and free newsletter at ArtistsNetwork.com.

135

Putting It All Together

Now that you have completed the projects in the book, you're ready to put all of the material together. Drawing the clothed figure is not an easy task. It is filled with hidden details that must be understood and fully captured for the artwork to make sense. Take this subject in stages.

I cannot stress enough how important the five elements of shading are! Do not skim over the beginning projects—they are important to your development.

Each element of human anatomy should be studied individually, before you start to draw the entire body. Learn this so drawing clothing will make more sense. The body is the framework for which the clothing is built on.

Study each element of the five folds found in fabric, before drawing an entire garment. The realism is found in the small details within the creases and folds.

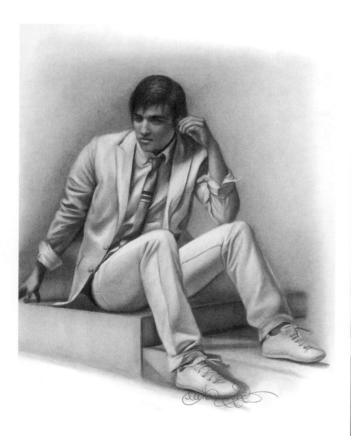

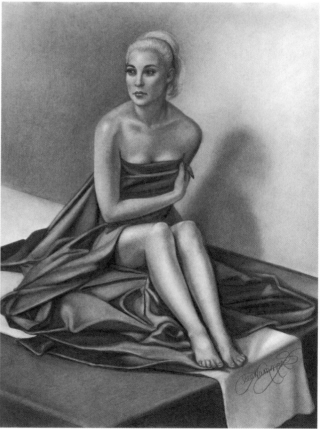

This casual pose is all about the lighting. The blended background helps create the light source, making the subject appear to be outside. The clothing is illuminated.

This look is high fashion and is definitely about placing all of the attention on the clothing.

This pose is about drawing the human form. This woman was a model for an art class, and the draped fabric was placed strategically to give the artists practice drawing the folds. Notice how it is falling down around her to create column folds and inert folds.

The lighting was also placed in such a way that a wonderful shadow was cast to the right, giving this piece a feeling of depth and dimension.

Every inch of the drawing paper was used here, with no white left showing.

When looking for things to draw, search for extreme lighting like you see here. It is the use of light that makes artwork so intriguing. The Old Masters said that it wasn't so much about the subject as it was about the effects of light on the subject. Those are good artistic words to live by.

The second image is a cute rendering of my great-grandson, Zander. It is an illustration depicting life. It does more than give us a glimpse of what he looks like—it tells us about his personality (active).

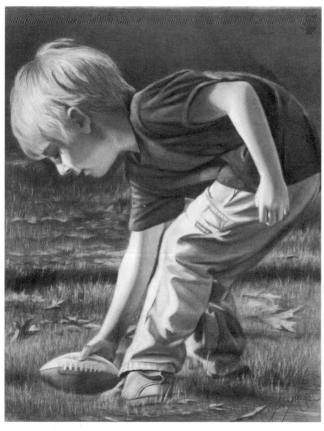

Colin At the Park
11" × 14" (28cm × 36cm)
Graphite on smooth bristol

I love the way the lighting is bouncing off of my grandson Colin's head and pants, creating such wonderful patterns. The edges of his arms are being illuminated, as well as his nose and cheeks.

Zander Learning to Run
11" × 14" (28cm × 36cm)
Graphite on smooth bristol

The plaid shirt is what makes this drawing so interesting. Never avoid difficult subject matter. If you do, you will leave a portion of the story untold!

Test Your Knowledge

· · · · · · · · · · · ·

See if you can find and identify these important things:

- Coil, or Spiral Folds
- Drape Folds

- Interlocking Folds
- The Five Elements of Shading
- The Cylinder Exercise
- Hard Edges

- Soft Edges
- Lifted Highlights
- Reflected Light

Find the answer by visiting: ArtistsNetwork.com/draw-realistic-clothing-and-people.

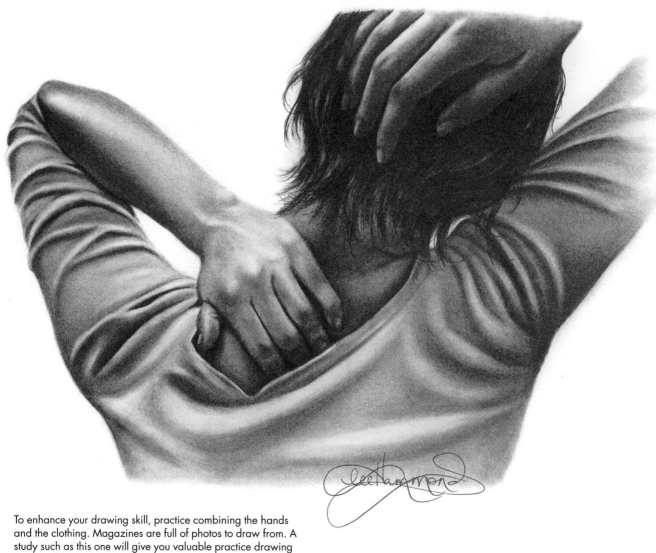

To enhance your drawing skill, practice combining the hands and the clothing. Magazines are full of photos to draw from. A study such as this one will give you valuable practice drawing both the folds of fabric and the details of the hands.

Study this drawing for a reminder of what we have covered so far.

Visit ArtistsNetwork.com/draw-realistic-clothing-and-people for bonus materials.

Conclusion

Well, here I am at the conclusion page of yet another book. It has been a wonderful adventure writing this one. It is so different from the ones I have done before, and took me in directions I never saw coming! I did illustrations that I never thought I'd do on my own. All of this was done with you in mind, to teach you and inspire you.

When writing a book, I become highly motivated. The projects and exercises in this book have now inspired me to create bigger and better pieces, all about the clothed figure. It is a wonderful topic! Thanks to you, I see even more interesting drawings looming in my future.

The pages on drawing statues has especially made me eager. Now I want to do more drawings of sculpture, especially ones of angels! Having studied the information that I have just written about, I now know how to do it even better. Thank you! I can feel it—a masterpiece is awaiting me!

Most people do not realize how much a teacher learns by teaching. When you have to explain things to your students, you vicariously teach yourself. Information that needs to be carefully spelled out for the student starts to make more sense, even to the teacher. Artwork that needs to be created in order to teach becomes more meaningful and thought provoking, even to the artist creating it. When having to think things through so completely, in order to describe it to someone else, you become much more aware and sensitive to your subject matter. I have had quite an education writing this book.

Whenever I finish a book, I am completely amazed at how it turns out. I never really know what the ultimate book will look like when I'm at the beginning. It's an exciting process. It isn't until the very end, that I can see how all of it is going to come together. When I finally turn over all of the material to my editor, and place it in the hands of the people at North Light Books, I know that they will make magic happen. They always do. What a wonderfully skilled group of professionals I work with!

Whenever I see my published book for the first time, I know I am in the right place. I couldn't be more blessed!

Personally, I think that this book turned out very unique. I tried extremely hard to make it different and interesting for an aspiring artist. I hope that it has taught you well, inspired you and urged you on to become even better with your own personal art.

There will be many more Lee Hammond books in the future, so stay tuned. This is my love. This is my life. Thank you for allowing me the pleasure of sharing what I do with you.

Until next time, keep practicing!

Gavyn
11" × 14" (28cm × 36cm)
Graphite on smooth bristol

Index

Visit ArtistsNetwork.com/draw-realistic-clothing-and-people for bonus materials.

About the Author

Polly "Lee" Hammond has been a professional artist for more than thirty-five years. She has engaged in numerous art-related careers, including police forensics. She is on call for the Kansas City area police departments to render composites from description, age progressions and reconstruction. She has also worked on many true crime shows, including *America's Most Wanted*.

Lee has also been a billboard illustrator and painter, as well as a licensed NASCAR® illustrator. Her main love, however, is teaching. She specializes in art instruction, teaching all mediums and all subject matter. As a result, she has authored many North Light Books and is one of their best-selling authors. She continues to produce art-related books and DVDs annually.

Lee is also a public speaker and the author of a motivational book titled *REACH*. She has also authored dozens of motivational children's books, which she is currently illustrating.

Lee lives in Overland Park, Kansas, during the warm weather months, where she owns and operates her own teaching studio. There, she teaches and writes full time. She has a service dog named Jackie. As a team, they are trained members of Pet Partners and volunteer at medical facilities, offering pet therapy to those in need. During the winter months she resides in Naples, Florida, where she teaches at the Rookery Bay Research Reserve and devotes herself to her writing.

Her website (ArtistNetwork.com/lee-hammond) is now a part of the Artists Network, and she blogs weekly about her life and her art. Visit it often for new adventures and fun-filled stories, as well as information answering many of your art-related questions.

a content + ecommerce company

Other fine North Light Books are available from your favorite bookstore, art supply store or online supplier. Visit our website at fwmedia.com.

22 21 20 19 18 7 6 5 4 3

DISTRIBUTED IN THE U.K. AND EUROPE
BY F&W MEDIA INTERNATIONAL LTD
Brunel House, Forde Close, Newton Abbot, TQ12 4PU, UK
Tel: (+44) 1626 323200, Fax: (+44) 1626 323319
Email: enquiries@fwmedia.com

ISBN 13: 978-1-4403-3514-3

Edited by Brittany VanSnepson and Mona Clough
Designed by Elyse Schwanke
Production coordinated by Mark Griffin

METRIC CONVERSION CHART

To convert	to	multiply by
Inches	Centimeters	2.54
Centimeters	Inches	0.4
Feet	Centimeters	30.5
Centimeters	Feet	0.03
Yards	Meters	0.9
Meters	Yards	1.1

Acknowledgments

There are few people outside of the publishing industry who truly understand the complexities of writing and publishing a book. So much goes into it, and it can be a very lonely process. Like any other creative endeavor, much of it has to be done in solitude.

In my case, I am so lucky to have a whole troop of people who truly understand what I go through. Those people are my students. Daily, they watch me draw the many illustrations that go into my books, and they learn from them. They encourage me. They see me come to the studio to teach a class totally exhausted, after working into the wee hours on a deadline. Yet they never complain or act cheated by my fatigue. They are creative people too, and they understand my passion. They are happy just to be there, even if I am operating on only three hours of sleep.

I would be nowhere in this career without the endless support of my students, readers and fans. How lucky I am to have them! I never take them or this awesome career for granted. It is my deepest desire to keep on producing books that people love for many, many more years. I hope to inspire in each of them a passion for art as strong as mine!

I must also commend my family for their understanding. My kids grew up under a drawing table, and now my grandchildren and great-grandchildren will see me as "the creative one." I love having them in the studio to share the fun. I love you all, more than you'll ever really know!

Dedication

This book is dedicated to everyone at North Light Books and F+W. For more than two decades, these wonderful people have indulged my endless creativity.

A huge thank-you goes out to Jamie Markle and Mona Clough: They have been there working with me every step of the way. What started out as a dream of simply having a single book published has turned into a career—thanks to them. Now, with both of them still by my side, they are turning my career into a dream come true! We've come full circle.

I also want to thank Brittany VanSnepson for all of her hard work and patience in putting this book together. I do things a bit differently than most authors, and she was awesome at allowing me to break the rules. Thanks, Brittany, for your kind guidance and understanding.

I know that with these fine people and their help, along with all of the other hardworking folks at F+W, the next twenty-plus years of working together will be just as amazing as these last twenty! Here's to many more books and dreams come true!

I also want to dedicate this book to the love of my life, Penny the Wonder Dog, who I lost recently. There has never been a bigger hole in my heart. Many of you came to know this cute little girl, for I featured her in artwork in many of my books over the years. It's hard to believe that her entire life has come and gone already. It all went by so quickly. I will always miss you, Penny-girl. You were very special to me!

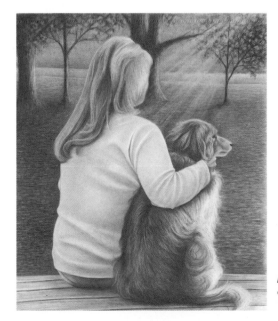

Me and Penny in Better Days
Graphite on smooth bristol
14" × 17" (36cm × 43cm)